HOW TO DRAW FUN STUFF

STROKE BY STROKE

JONATHAN STEPHEN HARRIS

DK

HOW TO DRAW FUN STUFF

STROKE BY STROKE

JONATHAN STEPHEN HARRIS

Publisher Mike Sanders
Senior Editor Brook Farling
Designer Lindsay Dobbs

First American Edition, 2021
Published in the United States by DK Publishing
6081 E. 82nd Street, Indianapolis, IN 46250

Copyright © 2021 Jonathan Stephen Harris

23 24 25 10 9 8 7 6 5 4 3
003-326220-DEC2021

Published in the United States by Dorling Kindersley Limited.

ISBN: 978-0-7440-4791-2
Library of Congress Catalog Number: 2021931002

Note: This publication contains the opinions and ideas of its author(s). It is intended to provide helpful and informative material on the subject matter covered. It is sold with the understanding that the author(s) and publisher are not engaged in rendering professional services in the book. If the reader requires personal assistance or advice, a competent professional should be consulted. The author(s) and publisher specifically disclaim any responsibility for any liability, loss, or risk, personal or otherwise, which is incurred as a consequence, directly or indirectly, of the use and application of any of the contents of this book.

DK books are available at special discounts when purchased in bulk for sales promotions, premiums, fundraising, or educational use. For details, contact:
SpecialSales@dk.com

Printed and bound in China

Author photo on page 5 © Jonathan Stephen Harris

For the curious

www.dk.com

This book was made with Forest Stewardship Council™ certified paper—one small step in DK's commitment to a sustainable future. **For more information go to** www.dk.com/our-green-pledge

ABOUT THE AUTHOR

Born and raised in Burton-on-Trent, England, Jonathan Stephen Harris started his freelance artist career drawing portraits of people and pets and then moved on to creating custom tattoo designs and logo designs. His previous books include *The Art of Drawing Optical Illusions* and *The Art of Spiral Drawing*. Jonathan currently lives and creates art in Corpus Christi, Texas.

ACKNOWLEDGMENTS

I am extremely grateful to DK Publishing for giving me the opportunity to produce this book. And I would like to say a big thank you to my editor, Brook Farling, for making this book possible.

I also would like to say a thank you to all my subscribers on YouTube and to everyone who has supported me online or in person over the years. It's because of you I am able to do what I love and what I feel I was created to do.

A huge thank you to my wife, Lydia, for believing in me and for allowing me to spend so much time away from her while I worked on this book. And a huge thank you to our two young daughters, Catalina and Chloe, who helped me pick out subjects and provided me with constructive criticism.

Finally, I would like to thank my mother for always being there and supporting me over the years.

DEDICATION

Dedicated to the memory of my art professor, Ron Falck. You may not have taught me for long, but you had the most impact on my art. Your approach to art helped me to become the artist I am today.

TABLE OF CONTENTS

The Basics . 9
 Tools & Materials 10
 Getting Started 12
 Tips for Setting Up Your Workspace 14
 Shading Techniques 15
 Creating Surfaces & Textures 18

Winged Things 23
 Treble Clef & Wings 24
 Butterfly Skull 30
 Heart with a Banner & Wings 36
 Phoenix . 42
 Flying Pig . 48
 Pegasus . 54

Celtic & Tribal 61
 Tribal Flames 62
 Celtic Eagle 68
 Abstract Dragon 74
 Splashing Koi Fish 80

3D Trick Art 87
 3D Ghost . 88
 3D Ladder . 94
 3D Spiderweb 100
 Snake Under Paper 106
 3D Ladybug 112
 Disappearing Letter A 118
 3D Cubed Hole 124
 3D Word (Art) 130

Animals & Insects 137
 Koala & Ice Cream 138
 Sea Turtle . 144

Scorpion . 150
Seahorse . 156
Monkey Astronaut 162
Praying Mantis 168
Skeleton Riding a Shark 174

Other Fun Stuff 181
 Shooting Star 182
 Heart Bubble 188
 Lips . 194
 Peacock Feather 200
 Eye . 206
 Guitar & Flames 212
 Loch Ness Monster 218
 Hawaiian Flower Cross 224
 Dragon Claw & 8 Ball 230
 Daisy with Falling Petals 236
 Masquerade Mask 242
 Apple Skull 248
 Chopper Motorcycle 254
 Tumbling Dice 260
 Fairy . 266

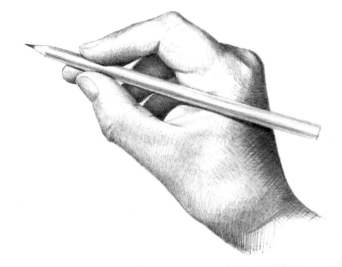

INTRODUCTION

Learning to draw is no different from learning any other artistic ability. When learning to play a musical instrument, for example, there are basics you must learn in order to play music, but once you know those basics, you are then able to use what you have learned to create your own tunes that are just as good as, or even better than, the originals. Drawing works the same way. You first learn the basics and practice until you feel comfortable with your drawing skills, and once you know how to draw, you can put together anything your mind can imagine. There are no limits to what you can draw.

I wanted to produce a how-to-draw book showcasing captivating subjects that inspire the imagination. I firmly believe that drawing fun and cool subjects not only stimulates the brain, but also helps you stay engaged in the act of drawing longer, which in turn makes you learn faster. This book offers many different projects for you to draw, including 3D trick art, fantasy art, stylized designs, and more. And each subject is broken down into easy-to-follow steps. I hope this book will inspire you to pick up a pencil and try for yourself!

Jonathan Stephen Harris

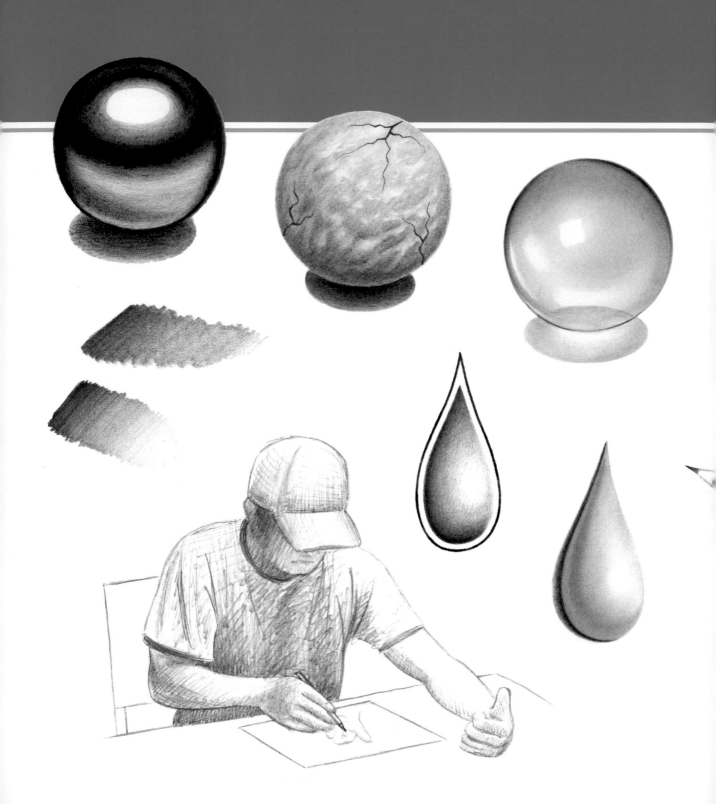

THE BASICS

Before you begin the projects in this book, it will be helpful to know what kinds of tools and materials you'll need to create your drawings. Additionally, if you're a new artist, there are some exercises for shading as well as some simple tutorials for creating surfaces and textures that will help you practice some of the basic drawing skills that every new artist needs to master. And if you're already an experienced artist, these tutorials will be a fun way to warm up.

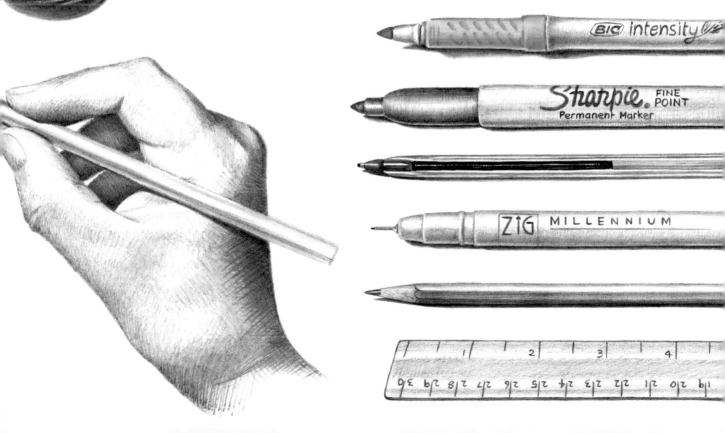

TOOLS & MATERIALS

One of the great things about drawing is that you don't need a lot of expensive tools to do it, and you can do it just about anywhere.

TOOLS

Here are the basic tools you'll need to draw every project in this book.

Pencils

There are so many pencils on the market today, it can be overwhelming for new artists. I find most pencils are basically the same; if it has lead, it will do the job. Any pencil marked "HB" (which means hard black) will work for basic drawings. An HB2 pencil, which has softer lead than an HB, will be useful for a few projects. Basic coloring pencils will work just fine.

Eraser

Erasers are important tools, and you want to make sure you have the right kind because the wrong eraser can damage your drawings. Look for kneaded or artgum erasers. And don't use the eraser on the end of a pencil; it can leave residue on your drawing or tear the paper.

Pencil sharpener

It's important to keep your pencils sharp, so keep a pencil sharpener handy.

Black fineline pen

A black fineline pen is another important tool that will help you define lines and outline your drawings. Look for fineline pens that are waterproof and permanent.

Blue ballpoint pen

Although this is not an essential tool to have and isn't really used for drawing, it can come in handy for some projects. You'll want to have one for one of the 3D projects in this book.

Black and gray marker pens

A black marker pen is handy for filling in large areas that need to be completely black and are too large to fill in with a black fineline pen. Sharpie makes a reliable and affordable black marker pen.

Ruler/straightedge

A basic ruler will come in handy as a straightedge and also for measuring and marking distance for 3D drawing projects. If you don't have a ruler, a simple straightedge will work for most projects.

Coloring pens

Coloring pens are useful for adding color to your drawings where coloring pencils won't do the job sufficiently, particularly in larger areas. They're also good for adding shading to larger areas that require color.

Scissors

A sharp pair of craft scissors will be useful for some of the 3D projects in this book.

MATERIALS

Here are the basic materials you'll need to get started.

Drawing paper

If you're using markers and coloring pens, a heavyweight paper works best because it's less likely to tear and buckle compared to lighter drawing papers. I like to use 110lb cardstock for most of my work, but you can use any heavier drawing paper.

Tissue paper

Tissue paper is important to have on hand so you can smudge areas to soften them. It's inexpensive, and you can find it at any art store, but if you can't find it, facial tissue or bathroom tissue will suffice.

GETTING STARTED

Before you start the projects in this book, there are a few things you should know that will help you become a better artist and also find more success in your drawings.

Hold the pencil the right way

The proper way to hold a pencil is known as the "tripod grip." To use the tripod grip, hold the pencil about 1 inch (2.5cm) up from the point, grasping it with the thumb and index finger and resting the pencil on the end of the middle finger. (Resting the pencil on the end of the middle finger gives it more support and stability.) Try not to hold the pencil with the thumb overlapping the index finger; holding it this way will limit what you can do, especially when you're trying to draw in a downward motion. Your hand will be free to draw all kinds of marks when you hold the pencil correctly.

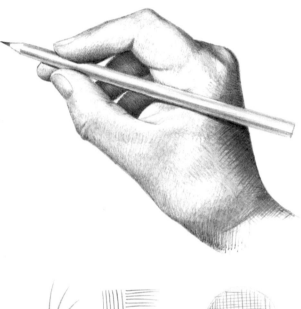

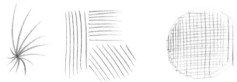

Keep the pencil sharp

When you're drawing the outline of something, you want those lines to be crisp, especially when you're drawing subjects with intricate lines, like eyes. If you can get yourself into the habit of keeping your pencil sharp, you will see a drastic improvement in your drawing.

Practice mark making

Practice making all types of lines: horizontal lines, vertical lines, diagonal lines, curves, circles, ovals, and so on. Try to get in the habit of doing this every day. It doesn't matter what you're doing because you're not drawing anything specific, just making marks. Plus, doodling is fun and awesome drawing practice!

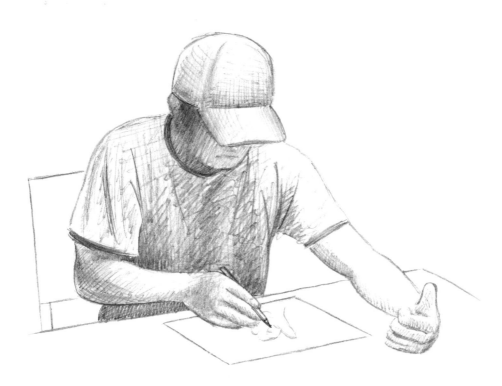

Keep observing your subject

You should be looking at *what* you're drawing more than you are looking at your drawing. You can train yourself to get into this habit. For instance, if you're drawing your hand, you'll want to be constantly looking back and forth between the drawing and your hand. Otherwise, you could get to a point and realize your drawing is off because you took your eyes off the subject instead of checking it as you drew it.

Try drawing your hand

This is great practice for a beginner because you are not drawing from a photo, but from life. This is pretty straightforward; just rest your nondominant hand in front of you while drawing with your dominant hand. Many people say that hands are one of the most difficult things to draw, so if you can master drawing your hand early, it will give you the confidence you need as you move forward.

Share your work

Get in the habit of showing off your work. Don't be afraid of criticism; both positive and negative feedback is good for growth and will make you a better artist. Keep in mind that some critics are overly positive, while some are looking for mistakes to point out, but each type of criticism can be helpful. Listen to the feedback and learn from it, and you'll be a better artist for it.

TIPS FOR SETTING UP YOUR WORKSPACE

You can draw anywhere and at any time, but having a dedicated workspace where you can concentrate is a really useful thing for any artist.

Find a quiet place to work

It's always good to have a quiet room or dedicated space that will serve as your workspace where you can draw uninterrupted. Ideally, you'll want to set up the space so you can get right to work whenever you want to draw, so try to find a space where your materials can be left out at all times and are close at hand when you're feeling inspired.

Set up a good drawing surface

Look for a sturdy desk with a smooth surface. Ideally, your desk will be adjustable and can be set at an angle, which can help when you're drawing certain subjects, but if that's not possible, a flat desk surface will work just fine. It's also good to have an adjustable chair so you can position yourself at the right height to your paper and be comfortable when you are drawing.

Use good lighting

If you set up your workspace near a window, you can use natural light as your primary light source. If you can't set up near a natural light source, however, you can set up a lamp and use daylight bulbs. Daylight bulbs can mimic natural light and provide a consistent light source, particularly if you like to draw at night.

Secure your drawing paper

When drawing, be sure to place the paper in a position where it won't move as you work. Loose sheets of drawing paper can be secured by simply taping down the corners with a few small pieces of masking tape. (Be extra careful when removing the tape.) If you're drawing in a sketchbook, the weight of the sketchbook should be enough to prevent excessive shifting.

SHADING TECHNIQUES

Shading is one of the most fundamental techniques to know when it comes to drawing. Shading is what makes a subject come to life or pop off the page, and the contrast in tones helps you depict certain areas within a subject. As an artist, you can use shading to your advantage to add emphasis to areas you want the viewer to see.

A good rule of thumb to remember when attempting to shade anything is that there are three basic tones: the darkest tone, the lightest tone, and the mid tone. Here is an example of a cube that shows the dark, light, and mid tones:

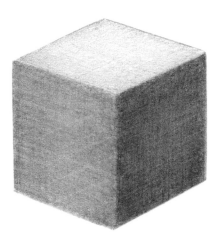

Proper shading technique

When shading, you want to use the side of a sharp pencil and hold the pencil using an overhand grip. You can adjust the amount of shading you add by changing the amount of pressure you apply to the pencil. You can also change the effect of the shading by how you angle the pencil.

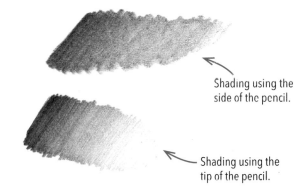

Shading using the side of the pencil.

Shading using the tip of the pencil.

There are many different shading techniques, but the two in particular I have used throughout my entire professional career are smudging and white space. I find these two techniques to be the most appealing in terms of design and aesthetics, and they can be learned quite easily with just a little bit of practice.

SMUDGING TECHNIQUE

Here is a simple exercise that will help you learn the smudging technique.

1. Using an HB pencil, draw a simple teardrop shape.

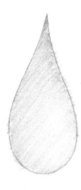

2. Shade the entire area with a light tone.

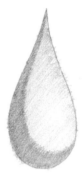

3. Shade the darkest tone.

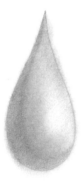

4. Using a piece of tissue paper, carefully smudge the entire area. (Smudging the dark tone against the light tone will create the mid tone.)

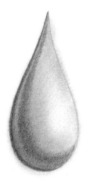

5. Apply more pencil to the darkest area (you'll lose some of it on the tissue) and then smudge the area again until the entire area is smooth.

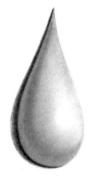

6. Highlight areas with an eraser and then use the sharp tip of a pencil to add the shadow.

WHITE SPACE TECHNIQUE

Here is a simple exercise that will help you learn how to use white space to create depth.

1. Using a black fineline pen, draw a simple teardrop shape.

2. Using the sharp tip of an HB pencil, define where you want the white space.

3. Outline the darkest areas with the tip of the pencil.

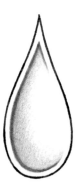

4. Shade the mid tone.

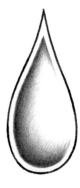

5. Apply more pencil shading to the darkest area.

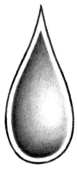

6. Apply the light tone and then gradually blend all three tones together.

CREATING SURFACES & TEXTURES

One of the greatest challenges for any new artist is creating surfaces and textures like glass, chrome, stone, or fur. But it really isn't that difficult once you understand the process. Here are some simple tutorials that will show you how to create some common surfaces and textures.

CREATING A GLASS SURFACE

Here's a simple tutorial for drawing a glass surface on a sphere.

1.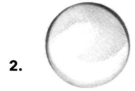

2.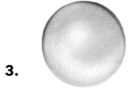

3.

4.

1. Using an HB pencil, draw a circle shape. Shade the entire area with a light tone

2. Shade some mid tone around the top half and around the lower bottom and then apply the darkest tone around the edges at the very top.

3. Touch up the areas outside of the circle with an eraser and then carefully smudge the entire area with a piece of tissue paper. (The smudging technique works really well for the glass surface.)

4. Use an eraser to add highlights and then use the tip of the pencil to apply more shading to the darkest areas. For more of a 3D appearance, add a shadow underneath the sphere, but keep in mind that with glass, the light source will be visible inside the center of the shadow and the shadow will be visible behind the sphere.

CREATING A CHROME SURFACE

Here's a simple tutorial for drawing a chrome surface on a sphere.

1.

1. Using an HB pencil, draw a circle shape. Mark out lines inside the circle for the dark tone, mid tone, and light tone by drawing a horizontal oval shape in the top half of the circle and then adding a smaller horizontal oval inside of the first oval. Add a thin, downward-pointing crescent shape above the smaller oval and then add a larger, wider, upward-facing crescent shape in the bottom of the circle.

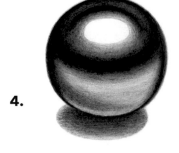

2.

2. Add dark shading in the small crescent as well as in the areas outside of the larger crescent and oval.

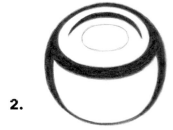

3.

3. Shade the entire area outside of the smaller oval with a light tone. Shade some mid tone around the top half and around the lower bottom portion of the sphere. Apply the darkest tone to the very top and around the edges.

4.

4. Carefully smudge the entire area outside of the smaller oval with a piece of tissue paper. Use an eraser to add highlights and then use the tip of the pencil to apply more shading to some of the darkest areas. For more of a 3D appearance, add a shadow below the sphere.

CREATING A STONE TEXTURE

Here's a simple tutorial for drawing a stone texture on a sphere.

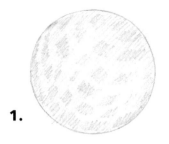

1.

1. Using an HB pencil, draw a circle shape. Apply a light tone across the entire area and then shade several small areas for the mid tone.

2.

2. Use a piece of tissue paper to lightly smudge over the area and then use the tip of the pencil to begin to build the dark tone.

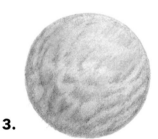

3.

3. Carefully smudge the area again with the tissue paper and then use an eraser to clean up the edges.

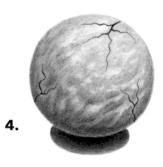

4.

4. Continue defining the rough areas of the stone by applying the darkest tone with the tip of the pencil. Draw cracks for extra appeal and then highlight the lightest areas with the eraser. (These marks help give the surface more texture.) If desired, shade a dark shadow underneath the sphere.

CREATING A FUR TEXTURE

Here's a simple tutorial for drawing a fur texture on a sphere.

1.

1. Using an HB pencil, lightly draw a circle shape and then draw curved spikes around the outside edge that all flow in the same direction. (This will almost resemble a circular saw blade.)

2.

2. Continue drawing curved spikes around the inside of the circle in a spiral shape until you reach the center of the circle.

3. Apply light shading throughout the drawing and then apply a darker tone to the left side and bottom of the sphere.

3.

4. Use a piece of tissue paper to lightly smudge the image, making sure not to smudge the areas around the outer edges. Use an eraser to highlight the ends of the fur spikes around the right side and center of the sphere. If desired, shade a shadow underneath the sphere.

4.

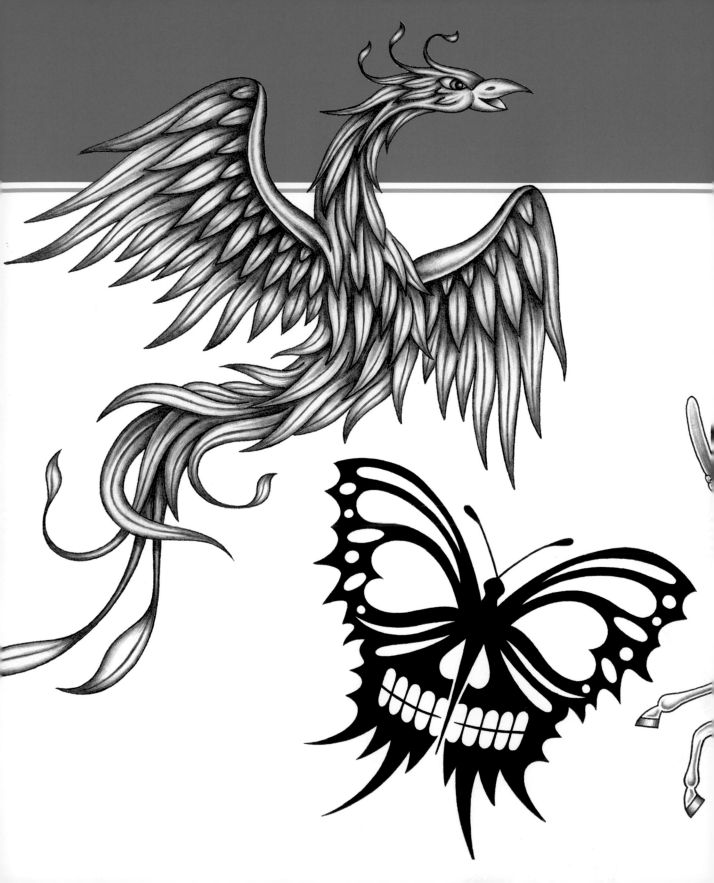

WINGED THINGS

Wings come in all different shapes and sizes and can offer unlimited visual appeal. It's helpful for artists to learn how to draw wings because they can teach you about symmetry and design. There are many interesting drawings you can create once you master drawing wings. In this chapter, I don't limit wings to the subjects they typically accompany; I cover a variety of subjects that feature different styles for all skill levels.

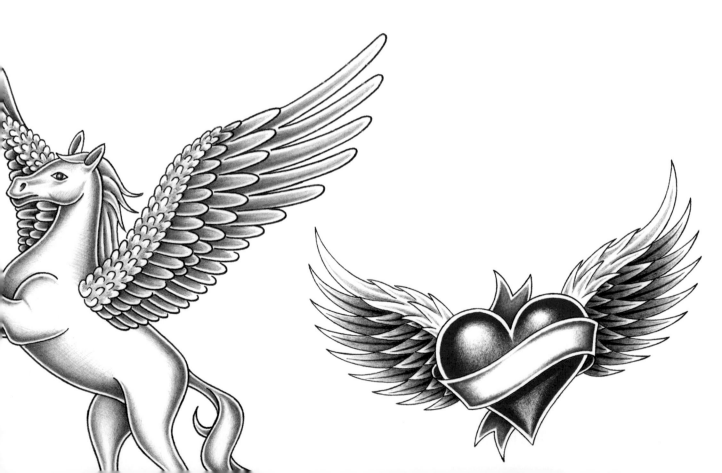

LEVEL ● ○ ○ ○ NUMBER OF STEPS 10

The treble clef is a symbol in musical notation that shows which notes are to be played. The large swirl that drops down from the top and wraps into the center is a very appealing aspect of the design. Adding wings can mean different things to different people, but I personally see it as a whimsical element to add to something that makes your heart soar.

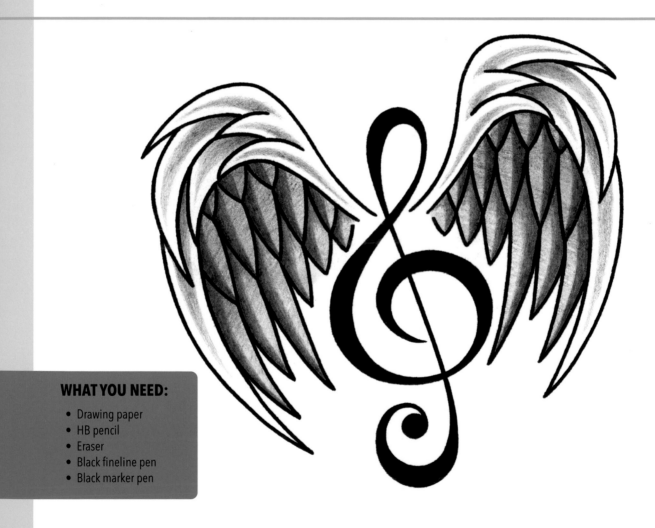

WHAT YOU NEED:

- Drawing paper
- HB pencil
- Eraser
- Black fineline pen
- Black marker pen

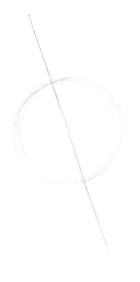

1 Using an HB pencil, begin lightly sketching a circle by moving your hand in a circular motion above the paper. When you see the circle in your mind's eye, gently place the pencil on the paper, still moving your hand in a circular motion, and draw continuously until you see the circle appear on the paper. (Note that it doesn't have to be a perfect circle.)

Draw a diagonal line through the center of the circle that is approximately twice the width of the circle.

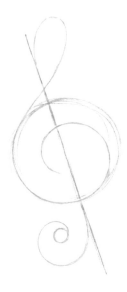

2 Begin drawing a swirly line that starts near the top of the diagonal line and then snakes down to the left and under the circle, gradually bending inside the circle and curling into the diagonal line.

From the bottom of the circle and at a point on the diagonal line, draw another swirly line that curls down to the left and then curls back in before it reaches the diagonal line. Draw a small circle on the end of this line.

3 With the basic layout of the treble clef in place, stylize the design by drawing a line around the figure that tapers at the points where the symbol bends.

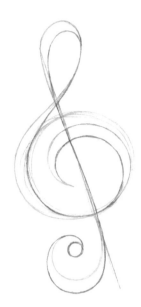

4 Using a black fineline pen, trace over the treble clef and then erase the guidelines. Proceed to the wings by drawing a diagonal guideline above the symbol and a second guideline through the bottom portion of the symbol that is parallel to the top line.

Draw two matching curves from the top cross section of the treble clef that swing up to the top guideline and then sharply bend and curve down to fall on the bottom line. Draw a second set of curved lines that follow the same path and fall inside the first set of lines before tapering to a point at the bottom.

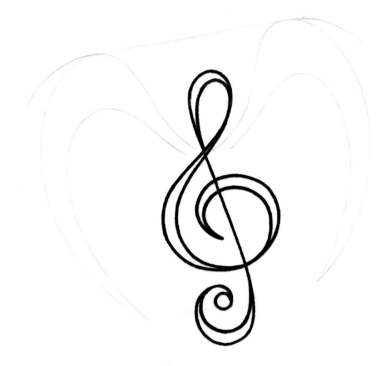

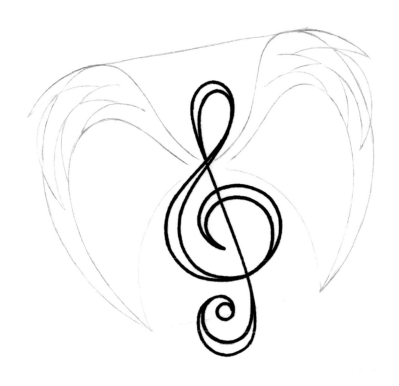

5 With the outside edges of the wings in place, it's time to draw in some feathers. Starting on one side, draw some curves that taper into points and then mark out a line for the bottom edge of the wing. Repeat the same process on the opposite side.

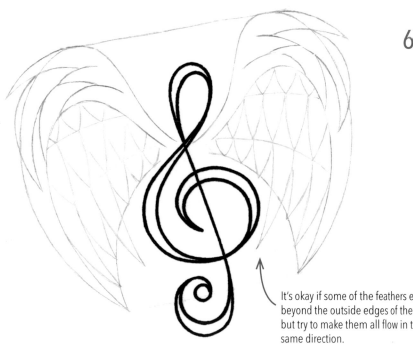

6 Add feathers to the insides of the wings by splitting the wing sections into three rows and then drawing cone shapes on each row.

It's okay if some of the feathers extend beyond the outside edges of the wings, but try to make them all flow in the same direction.

7 Using the black fineline pen, trace around the image and then erase any pencil marks.

Don't completely connect the wings to the treble clef. This will help keep the shape of the treble clef more defined.

The feathers at the top should be the shortest, and the ones at the bottom the longest.

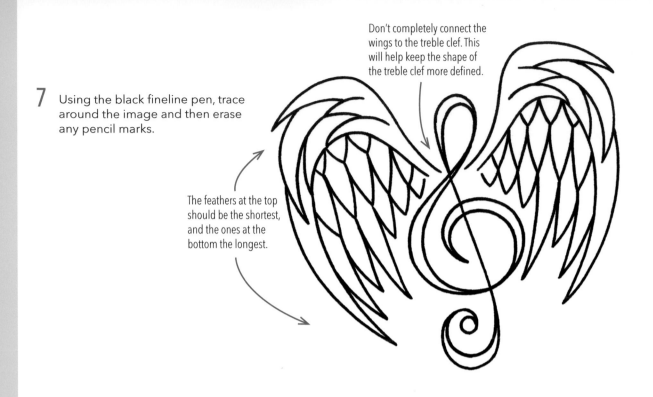

8 Use the black marker pen (or any other colored marker you desire) to fill in the treble clef.

Using the HB pencil, begin adding shading to the wings.

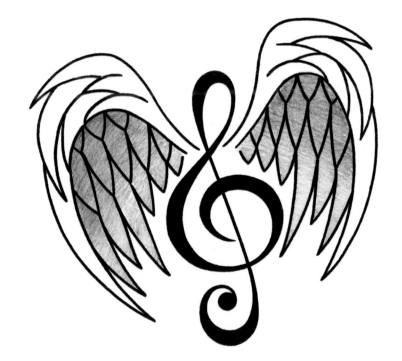

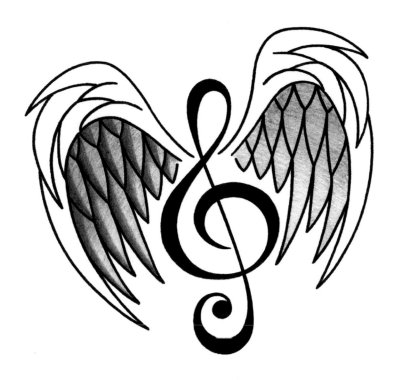

9 Darken one side of each feather on the left wing to create a 3D look. Complete the process on the opposite wing.

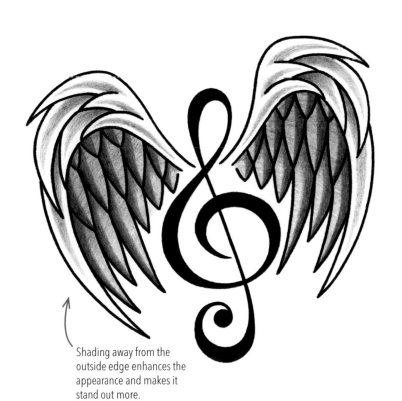

10 Add some light shading to the top feathers on the outside of the wings.

Shading away from the outside edge enhances the appearance and makes it stand out more.

BUTTERFLY SKULL

LEVEL ●●○○ NUMBER OF STEPS 8

The butterfly skull is a symbolic representation of the circle of life—the skull means mortality, and the butterfly means new life. With that in mind, it's no surprise why these designs are such a hit with tattooists and artists alike; they are fun to draw, and the design itself knows no limits.

WHAT YOU NEED:

- Drawing paper
- HB pencil
- Eraser
- Black fineline pen
- Black marker pen

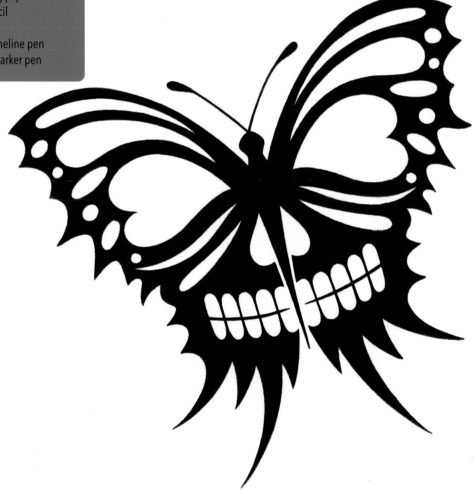

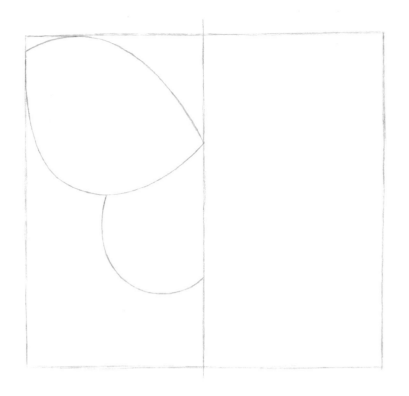

1 Using an HB pencil, lightly sketch a square and then split it into two halves by drawing a vertical line through the center. On the left side of the line, draw two curves starting approximately one third from the top of the vertical line. (These two lines should start from the same point and meet near the top of the outside square line.)

Draw an arc that starts just slightly left of center of the bottom curve and then stops at the vertical line.

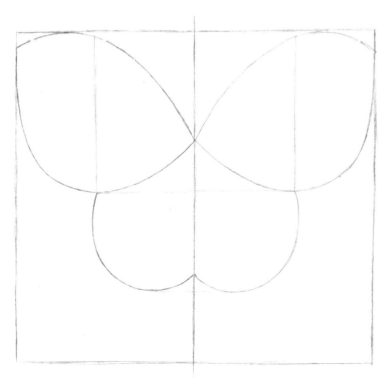

2 Add vertical and horizontal guidelines on the underside of the upper-left wing section and then mark out matching guidelines on the opposite side. Complete the upper and lower wing sections on the opposite side.

3 Draw a large teardrop shape that is slightly off center in the top left of the wing and then draw two elongated shapes above the teardrop that follow the line of the tear drop shape and the outside top edge of the wing.

Draw an elongated curved shape below the large teardrop shape that again follows the path of the teardrop shape and the bottom outside of the upper wing section.

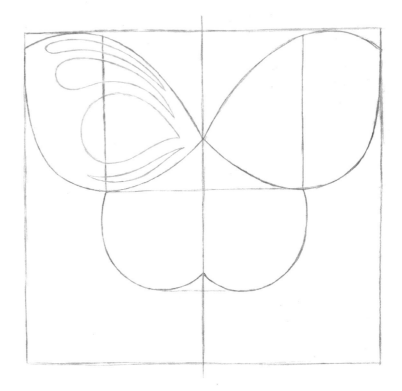

4 Add vertical guidelines on the left side. Determine the spacing between the vertical lines on the left wing, and add matching guidelines on the opposite side. Repeat the same process for drawing the wing detail on the right wing.

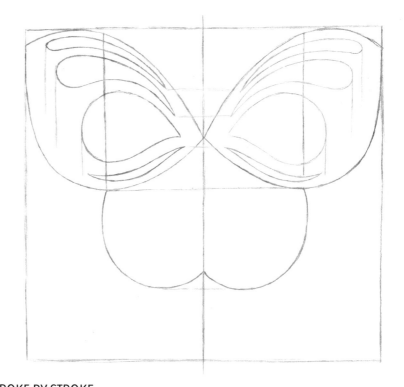

5 Draw an upside-down heart for the nose by drawing a mirrored, hook-like shape. Begin by drawing one side from the top center of the wings to below the central horizontal line and then repeating the process for the opposite side. Mark out two slight diagonal lines for the body that start at the top and on the inside of the nose and finish in the center of the bottom portion of the wings.

Begin drawing the mouth on one side by drawing a horizontal curve for the top of the mouth and a parallel one for the bottom. (The top corners of the mouth should line up approximately with the bottom of the nose and the center of the eyes.) Split the mouth in two by drawing a curve through the center. Add the teeth by spacing out equal vertical lines on either side. Finally, draw an elongated curve shape underneath the top sections of the wings.

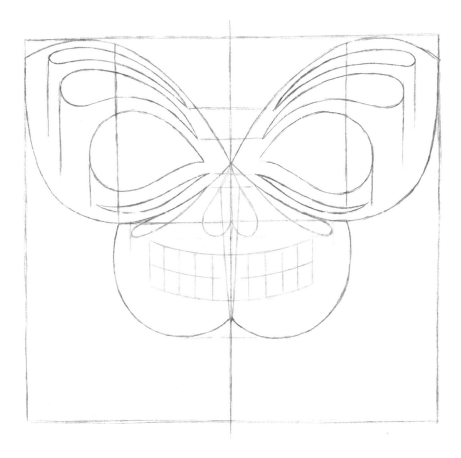

6 Now you can now start to add detail. Round off the teeth, draw a head, and then add the antennae. Give the eyes more shape and then draw some curves around the bottom edges of the lower wings to create a cool, jagged/spiky appearance.

Add a variety of different-sized oval shapes that are mirrored on both sides and placed inside the top portions of the wings. (This will give more emphasis to the eyes and make them pop.)

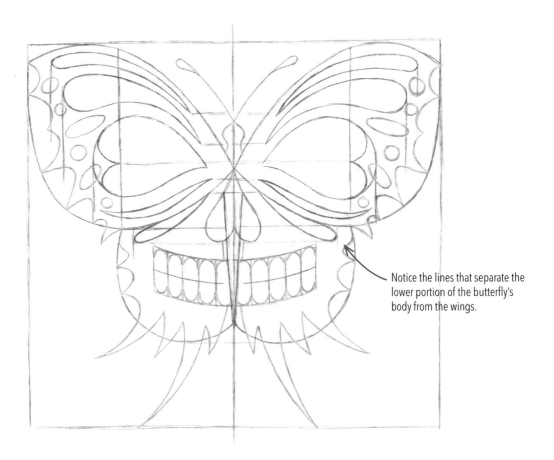

Notice the lines that separate the lower portion of the butterfly's body from the wings.

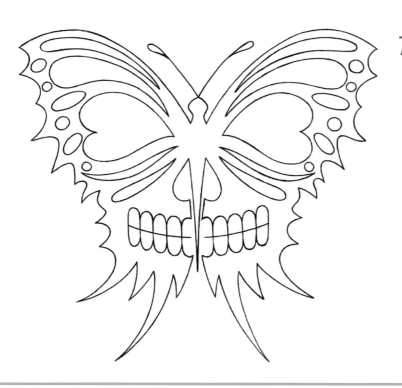

7 With a black fineline pen, trace around the image and then erase the guidelines.

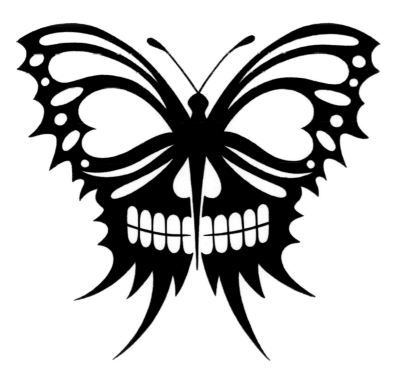

8 Use the black marker pen to fill in the lines.

LEVEL ● ● ● ○ NUMBER OF STEPS 10

A heart with a banner and wings is a popular design to draw. The heart shape, as we know it, came about during the Renaissance, but it became associated with love during the eighteenth and nineteeth centuries. Many people use this design to memorialize a loved one who has passed or to express a thought or motto that is important to them.

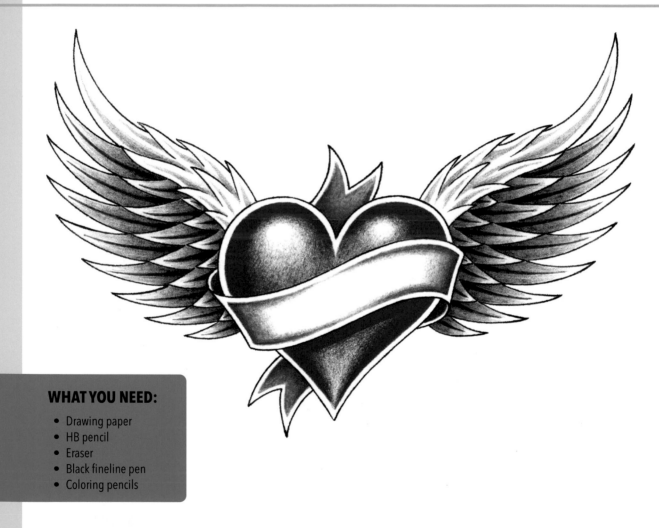

WHAT YOU NEED:
- Drawing paper
- HB pencil
- Eraser
- Black fineline pen
- Coloring pencils

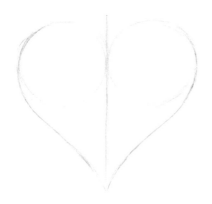

1 Using an HB pencil, sketch two side-by-side circles and then separate them with a vertical line.

Draw two curving lines from the outside edges of the circles and have them meet at the bottom of the vertical line.

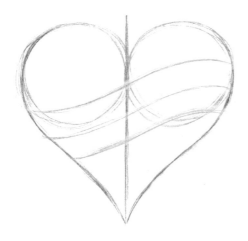

2 Draw a line that swings through the center of the heart from left to right and then draw lines above and below that line that follow the same path.

3 Draw an arc from the top left line that flows up toward the center of the heart and then draw the end of the banner with a triangular shape cut out of the end. Repeat this same process from the bottom left line and then close off both sides of the banner that stretches across the width of the heart.

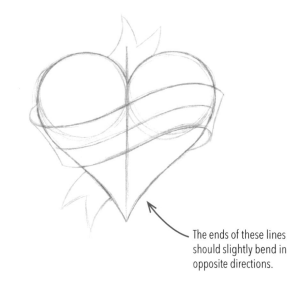

The ends of these lines should slightly bend in opposite directions.

4 Using a black fineline pen, outline the heart and banner and then erase all the guidelines inside the heart.

Begin drawing the wings by drawing a teardrop shape on one side and then adding a wavy line on the inside of the teardrop shape that flows with the outside line. Use the HB pencil to add guidelines to help with lining up the teardrop shape for the opposite side and then repeat the process to add the second wing.

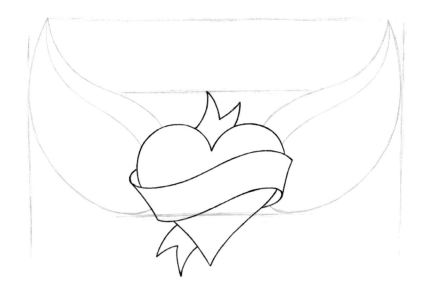

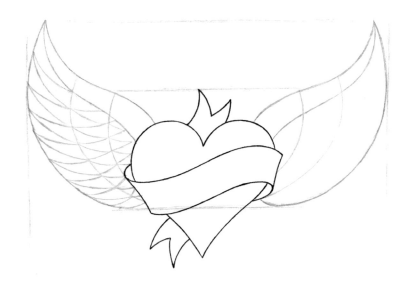

5 Split the wings into three sections by drawing two vertical curves in each wing that are evenly spaced. (These curves should swing down toward the heart, following the same path as the outside edges of the wings.)

Begin drawing the feathers by adding pointy cone shapes that flow in the same direction within each wing section.

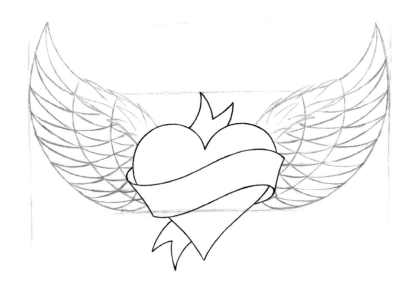

6 Once you've drawn the feathers inside each wing, draw in the feathers for the top portions of the wings. This can be achieved by drawing slender cone shapes on the sides and center that all flow in the same direction.

7 Once you're happy with the wings, trace over them with the black fineline pen and then erase any guidelines.

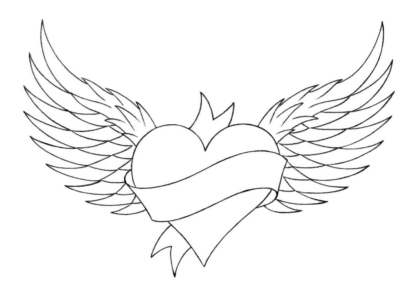

8 Now it's time to add color and some shading. With a red coloring pencil, shade around the outside of the heart, but leave a white space along the outside edges. Shade below the banner to give the impression of shadow.

Using a different colored pencil, add some shading to the banner, again leaving white space along the outside edges.

Using the HB pencil, add some shading to the inside feathers by separating each feather with a dark tapered line.

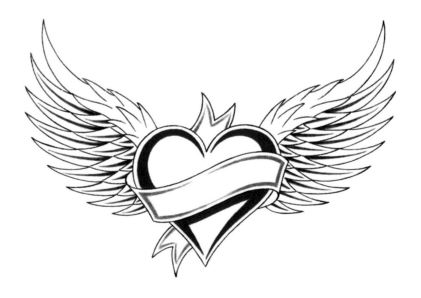

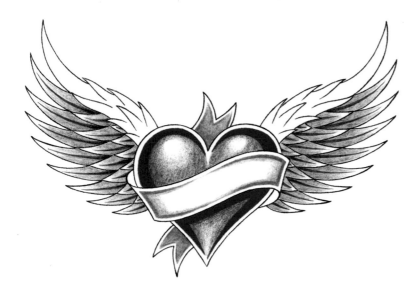

9 Using the HB pencil, shade the inside feathers in a consistent tone throughout.

Using the red coloring pencil, evenly shade the inside of the heart.

Using the color you chose for the banner, evenly shade the ends of the banner and then add a little shading to the face of the banner along the edges, but leave some white space toward the center.

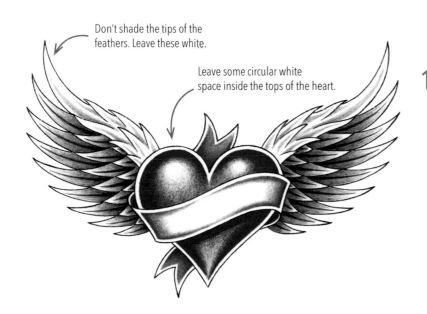

Don't shade the tips of the feathers. Leave these white.

Leave some circular white space inside the tops of the heart.

10 Shade between the darkest and lightest areas inside the heart and banner and then add some darker shading to the inside of each of the feathers. To make your banner stand out more, add a darker tone of color to the two arcs on either side of the heart and then, using this same tone, shade along the edge inside the banner.

Finish by lightly shading the feathers on the top sides of the wings.

PHOENIX

LEVEL ●●●○ NUMBER OF STEPS 9

The phoenix is a graceful mythical bird and a symbol of hope. Its long neck and tail enhance the aesthetic aspect, which makes it a fun creature to design and draw.

WHAT YOU NEED:
- Drawing paper
- HB pencil
- Eraser
- Black fineline pen

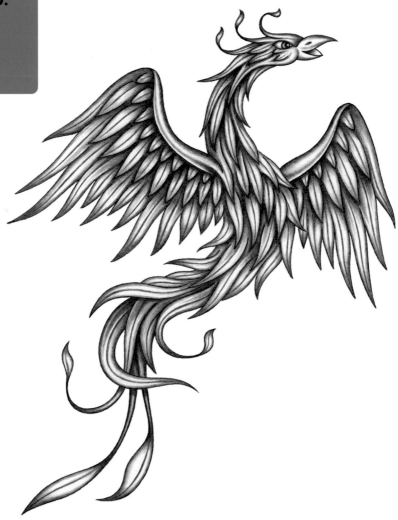

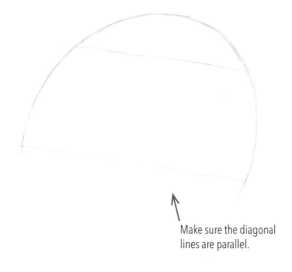

1 Using an HB pencil, lightly draw an arc with two diagonal parallel lines running through it. (This will serve as a guide for the width and height of the wings, so make sure the spacing between the lines is generous.)

Make sure the diagonal lines are parallel.

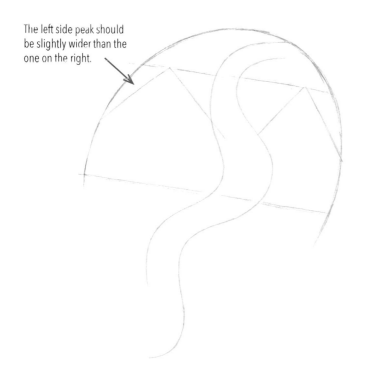

The left side peak should be slightly wider than the one on the right.

2 Draw two vertical wavy lines side by side through the center of the arc shape, creating a snake-like form. (This will serve as the guide for the body, so make sure the middle part is wider than the top and bottom.)

Draw two angled lines on each side of the body to create two peak shapes. Make sure the angled lines both flow in the same direction as the two diagonal lines from step 1.

3 With the guidelines in place, begin drawing the wings by adding the curvature of the top sides of the wings and then drawing in three large feathers on each side that taper at the ends.

Draw two arcs for the undersides of the wings. (These will help determine the placement for the feathers and the overall design and flow of the wings.)

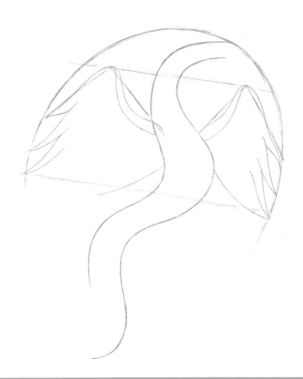

4 Complete the wings by drawing in the feathers. (For aesthetically pleasing designs, I find three rows of feathers works well.)

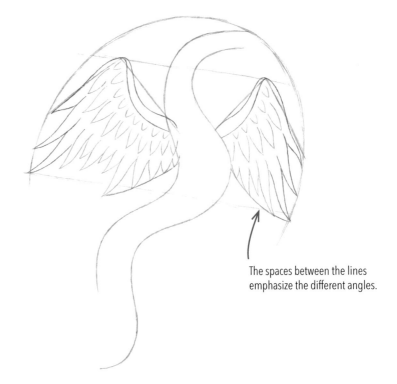

The spaces between the lines emphasize the different angles.

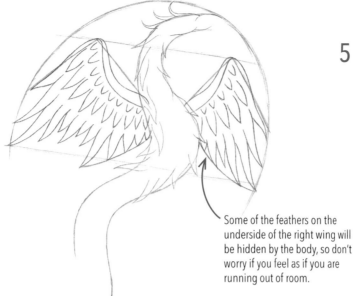

5 Now it's time to move on to the body. Begin by drawing in the outside feathers along the neck and body.

Mark out a couple of curves for the beak.

Some of the feathers on the underside of the right wing will be hidden by the body, so don't worry if you feel as if you are running out of room.

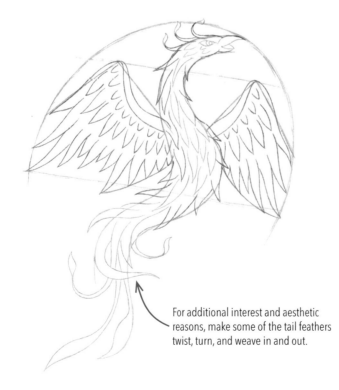

6 Complete the face by drawing in the rest of the beak and the eye.

Fill in the inside the body with feathers and then add some long feathers at the bottom for the tail.

For additional interest and aesthetic reasons, make some of the tail feathers twist, turn, and weave in and out.

HOW TO DRAW A PHOENIX **45**

7 Using a black fineline pen, outline the figure and then erase any guidelines.

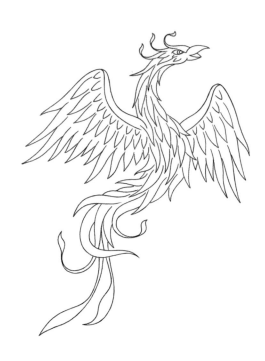

8 Using the HB pencil, apply some shading in the darkest areas between the feathers.

Draw a line through the center of each feather. Draw a nare (nostril hole) on the beak, and darken the mouth area.

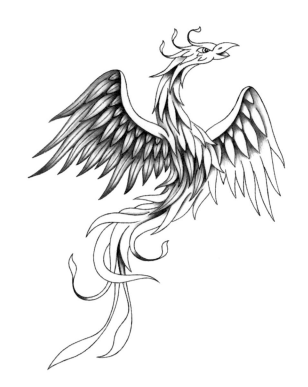

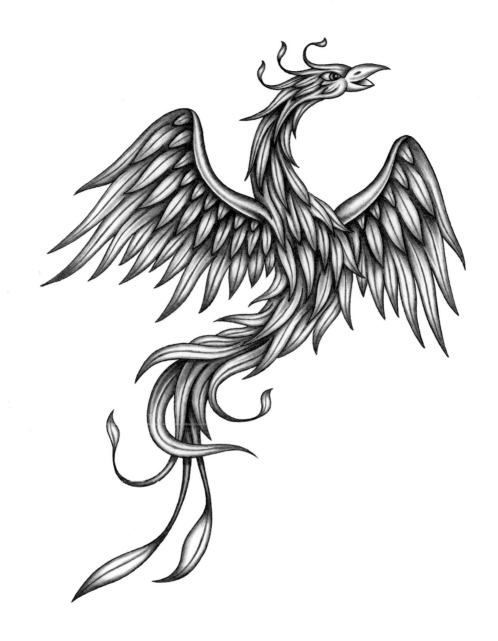

9 Continue the shading process until you are
satisfied with the result.

LEVEL ● ● ● ○ NUMBER OF STEPS 10

Most people have heard the phrase "when pigs fly," which is an offbeat way to describe something that will never happen. It's a silly phrase, but it's a funny thing to imagine and an even funnier thing to draw.

WHAT YOU NEED:
- Drawing paper
- HB pencil
- Black fineline pen
- Coloring pens

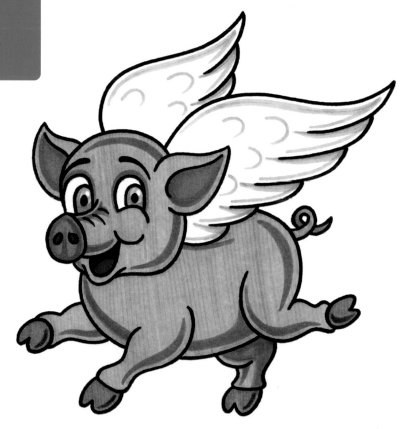

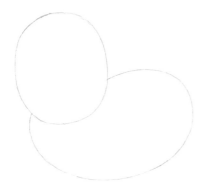

1 Using an HB pencil, lightly sketch a vertical oval shape for the head and a horizontal oval shape for the body.

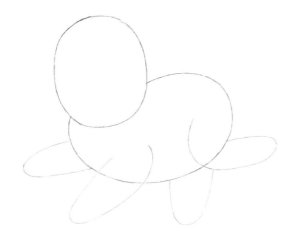

2 Draw four smaller oval shapes for the legs. The front facing legs should overlap the front of the body, and the back facing legs should curve up behind the body.

3 Draw two small leaf shapes for the ears. The left ear should sit behind the head, and the right ear should slightly overlap and sit on the right side of the head.

For the snout, draw a stretched letter "C" shape that starts slightly on the outside of the head shape, angles toward the bottom, and extends onto the left side of the oval.

For the wings, draw two large leaf shapes that extend from the back of the head. The wing that extends from the near side of the head should be the largest and should extend farther than the one behind it.

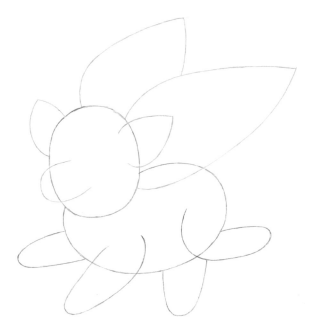

4 Draw wavy curves inside the top areas of the ears. Round off the end of the snout and then draw two slight curves inside the stretched "C" shape. Draw two arcs for the eyes and an upside-down arc for the top of the mouth.

Draw a curved line beneath the mouth that stretches out onto the face for the chin. Mark out an area for the cheek by drawing a slight arc beneath the right eye and another slight arc that points upward from the corner of the mouth.

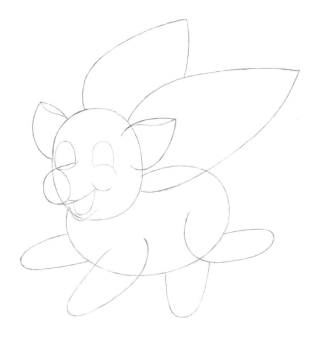

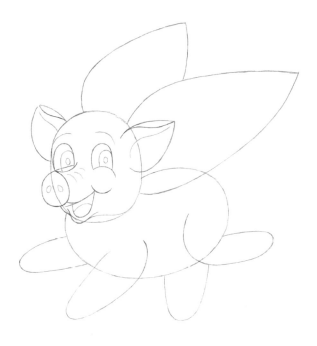

5 Add two small curves above the eyes and then add the irises and pupils. Add a small upward-pointing curve in the mouth to create the tongue. Add slight curves in the ears.

Complete the snout by adding two small ovals for the nostrils and then adding three curved lines to create wrinkles in the snout.

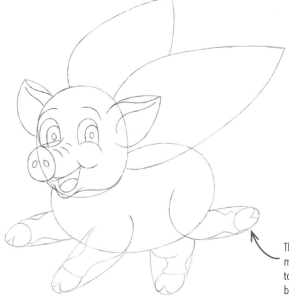

6 Define the legs by first drawing some "W" shapes for the hooves and then closing off the tops.

Draw wavy lines to form legs that taper toward the hooves.

The leg on the far right flicks up, so make sure the "W" leans on its side to give the impression that the bottom of the hoof is facing upward.

7 For the wings, start by drawing wavy curves inside the tops of the two large leaf shapes. (These two curves should slightly bend upward at the very ends.)

Divide the right side of the largest wing into six feathers by drawing six curves that sharply bend at the outside edge but then flow in a horizontal direction to the left. Repeat the process for the smaller wing, but add just a few lines because half of the wing is hidden behind the largest wing. Now add a few reversed "C" shapes and arcs to give the impression of feathers. Draw two curly lines that taper at the end to create the tail.

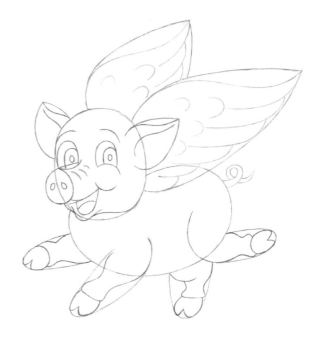

8 Outline the drawing with a black fineline pen, but don't outline the detail inside the feathers. Erase any guidelines.

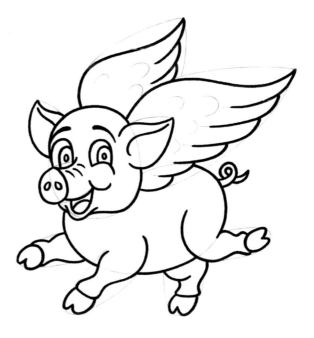

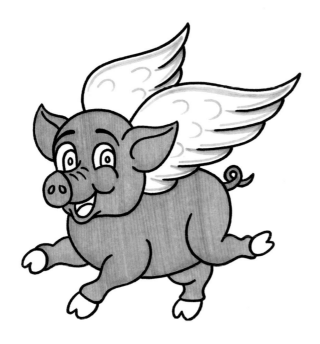

9 Using a blue coloring pen, shade the outer edges of the wings, leaving some white space along the edges and then trace the reverse "C" shapes.

Erase any remaining guidelines and then color the pig's body with a pink- or peach-colored pen.

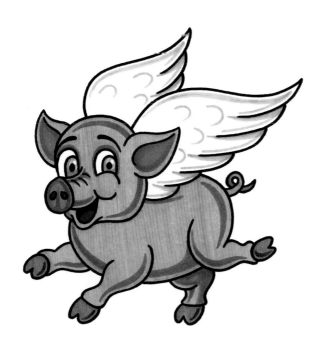

10 Use the black fineline pen to fill in the mouth and pupils. Use the blue coloring pen to shade the iris of the eyes. Use a brown coloring pen to color the hooves. Use a darker coloring pen to add some 3D effect to the hooves.

Use a red coloring pen to color the tongue and nostrils, and also add any additional shading around the pig's body.

HOW TO DRAW A **PEGASUS**

LEVEL ●●●● NUMBER OF STEPS 10

The Pegasus is a creature from classic literature. In Greek mythology, it's a beautiful white horse with magnificent wings that was thought to be the child of the god Poseidon and the creature Medusa. Regardless of where the idea of the Pegasus came from, it's easy to see why this graceful creature is a favorite of many artists to draw.

WHAT YOU NEED:
- Drawing paper
- HB pencil
- Eraser
- Black fineline pen

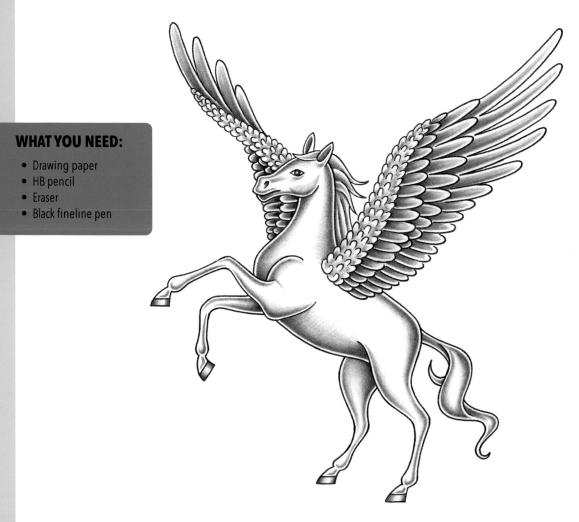

The right curve should start just past midway of the oval and flick up and to the left.

The left curve should start on the end of the left side of the oval.

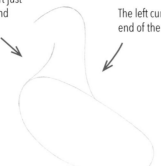

1 Using an HB pencil, lightly draw an oval shape, but make the top of the oval less curved than the bottom so it almost looks like a bean.

Draw two curves from the top left side of the oval to create the neck and top of the head.

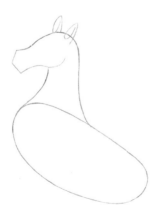

2 Draw a wavy curve above the left side of the neck. Draw a slight bend from the top curve, followed by a slight "V" shape for the nose that points to the left.

Draw two pointy cone shapes with ovals inside for the ears.

3 Draw the top portions of the legs. Draw two at the front that point toward the left and two more at the back that point toward the lower right.

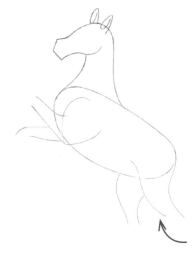

Try to make the legs wider at the tops by making the lines taper at the ends.

4 Draw the bottom portions of the legs by drawing curves on the sides of each leg that bend inward before curving back out and into rounded ends.

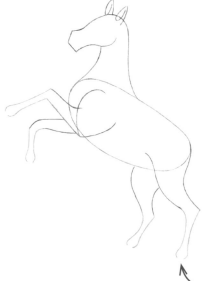

Try to make the bottom parts of the legs shorter than the tops of the legs.

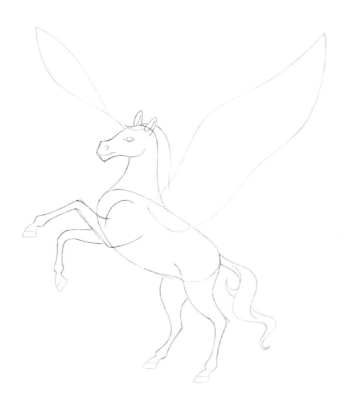

5 Round off some of the sharp corners and edges in the legs and nose. Draw the hooves and tail. Define the face, and mark out an area for the mane along the back of the neck.

Draw shapes for the right wing by drawing two long wavy lines from the top of the body that gradually taper into a point toward the top right. Draw shapes for the left wing by drawing a wavy line from the top left of the head that points up toward the top left and then draw a curve that swings back toward the head.

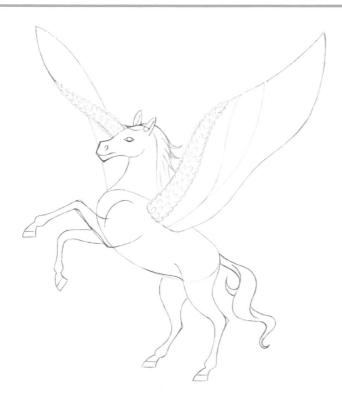

6 Add some detail to the mane. Create four sections inside the right wing by drawing three curved lines that flow with the direction of the outside of the wing.

Draw a curve on the left wing that tapers and flows from the head. Close off the underside of the wing by drawing a slight curve that bends toward the upper left and just behind the end of the nose. Draw several small arcs throughout the left section of the right wing and then do the same for the section on the left wing. (You may find it easier to draw the arcs along the outside edges first before drawing the arcs in the center.)

7 Draw small elongated arcs in the next two sections that flow in the same direction as the wing and then draw two rows of feathers for the left wing.

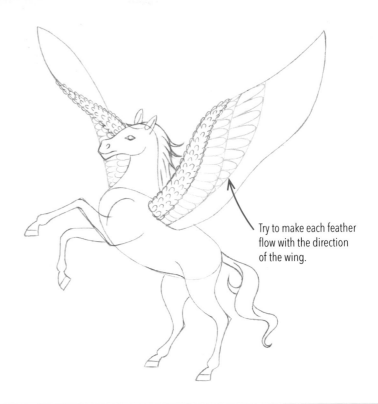

Try to make each feather flow with the direction of the wing.

8 Draw feathers inside the last section of the right wing and then do the same for the left wing.

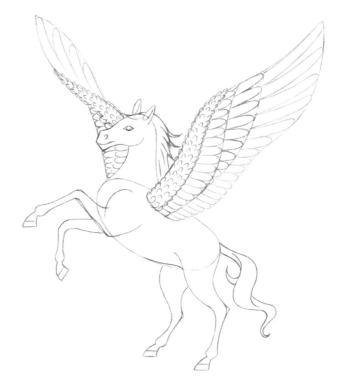

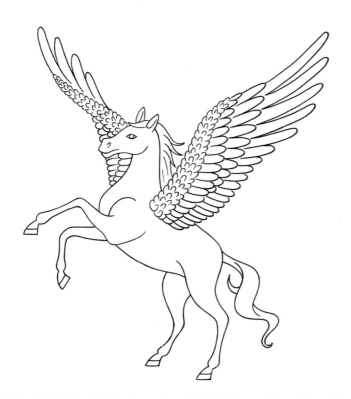

9 Using a black fineline pen, trace over the image and then erase any guidelines.

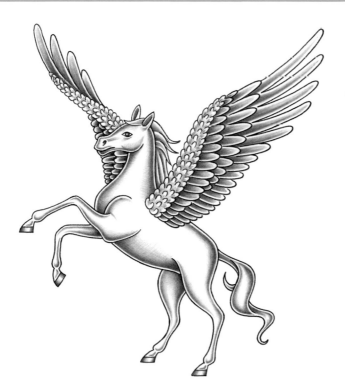

10 Using the HB pencil, begin shading by adding darker tones at the base of the feathers and on the underside of the horse. Try to leave some white space between the shading and the outside edges to create additional visual interest.

Continue shading until you are satisfied with the result.

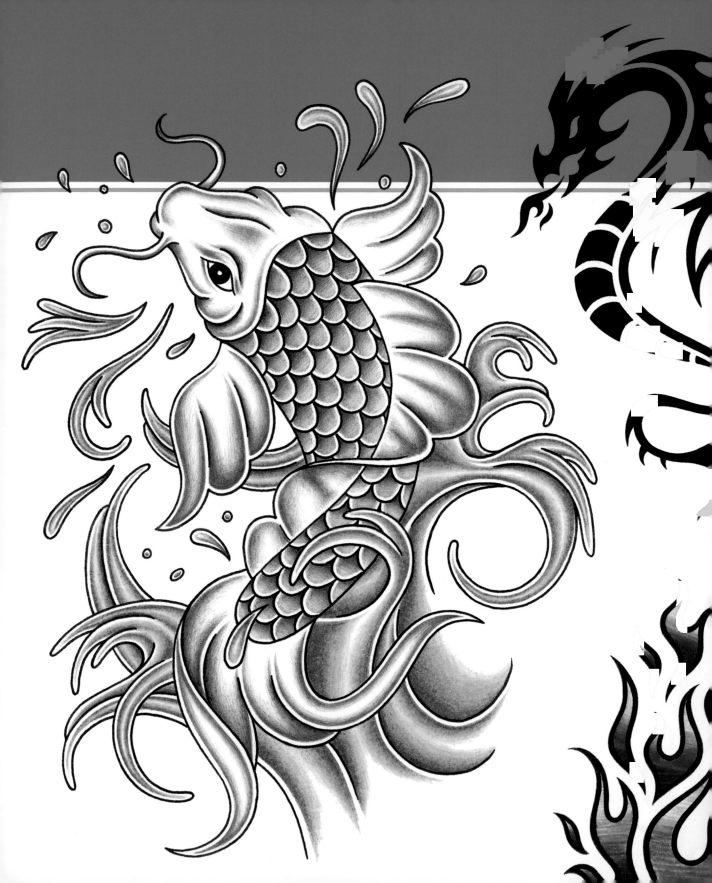

CELTIC & TRIBAL

Many people are drawn to Celtic and tribal designs. Celtic and tribal designs have long been used to decorate spaces because of their ability to fit whatever they inhabit; they can have a lot of impact no matter how bold or delicate you choose to draw them.
In this chapter, I've put together a variety of designs influenced by Celtic and tribal cultures that will teach you about negative space and design flow.

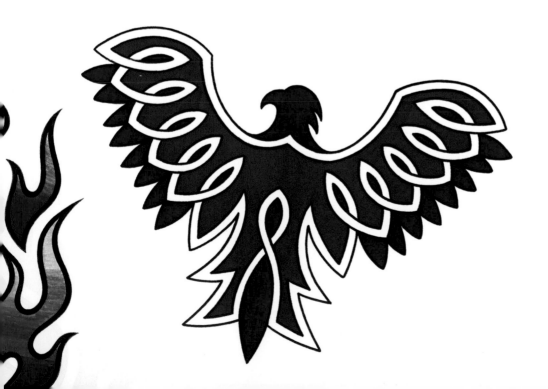

LEVEL ● ○ ○ ○ NUMBER OF STEPS 9

Fire can symbolize many things, depending on the context in which it is used, but in many cultures, it's considered a symbol of wisdom and knowledge. Flames have such an appealing design flow as they twist, turn, and point in the same direction. And the intense reds, oranges, and yellows only enhance the appeal from an artist's perspective.

WHAT YOU NEED:

- Drawing paper
- HB pencil
- Eraser
- Black fineline pen
- Black marker pen
- Coloring pens

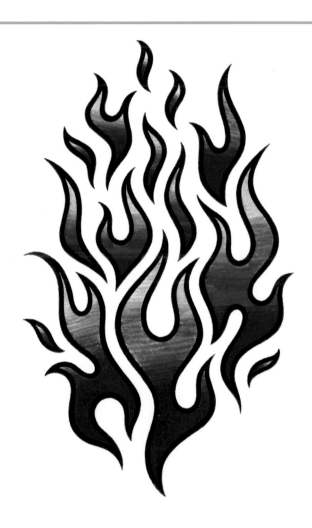

1 Using an HB pencil, lightly sketch an elongated egg shape. (The egg shape is just the area you will be working within.)

Draw a wavy line inside the shape that starts just above the center and falls on the bottom center of the egg shape.

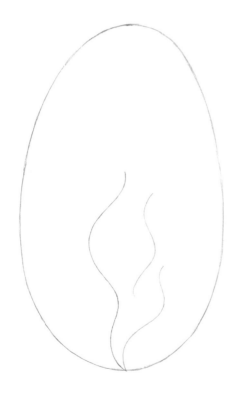

2 Draw a second, shorter wavy line that is about half the length of the first line, starts from the bottom, and stretches toward the right side of the oval.

Draw a third wavy line between the first two lines that stretches upward and slightly to the right.

3 Connect the wavy lines by drawing two sharp curves that follow the same path as the original wavy lines and then taper at the ends. Now you have your first flame established.

Begin drawing the next flame by adding a wavy curve that follows the same contour as the left side of the flame you just completed. Add two more lines to the left of that one that stretch upward and toward the left side of the egg shape.

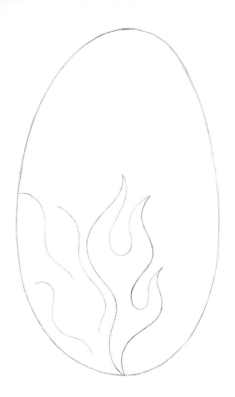

4 Following the same process as in step 3, connect the lines with sharp curves that follow the same paths and then taper the flames at the ends. Repeat the same process for the next flame on the right side of the egg shape.

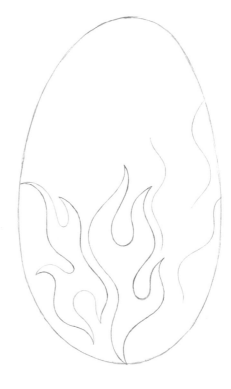

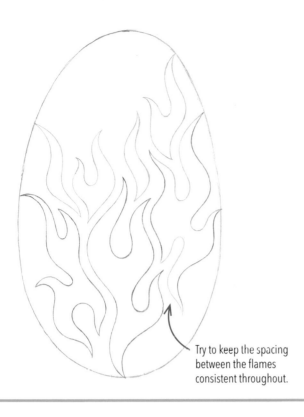

5 Continue progressing toward the top of the egg shape, following the same process to draw the flames but gradually making them shorter as you progress toward the top.

Try to keep the spacing between the flames consistent throughout.

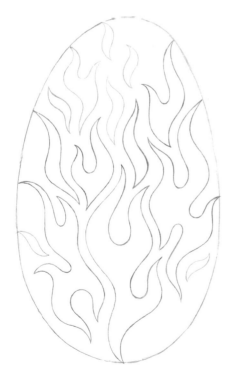

6 Draw two or three small flames at the very top and then add one on each side toward the bottom.

7 Trace around the image with a black fineline pen and then erase all pencil marks. Next, use the HB pencil to draw lines on the insides of the flames that follow the same paths as the outside edges. Once you're happy with the result, trace over the inside lines with the fineline pen.

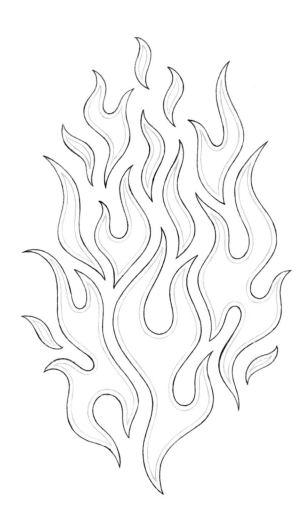

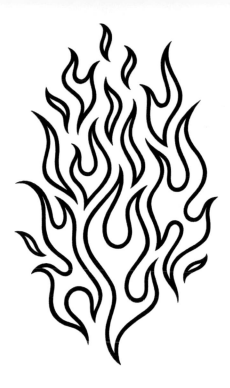

8 Fill in the lines of the flames with a black marker pen.

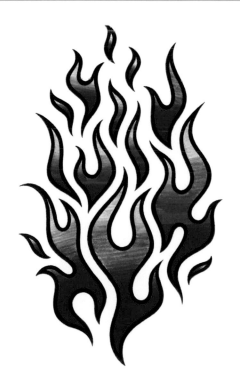

9 Now it's time to color in the flames with coloring pens. Use a red pen for the bottom portion of the flames, an orange pen for the center parts, and a yellow pen for the very tops.

LEVEL ●●●○ NUMBER OF STEPS 8

In Celtic folklore, eagles (or *drein*, as they were once called) were seen as ancients among birds, and as such were thought of as wise and powerful leaders. These captivating birds are always a joy to draw, and they really do command the viewer's attention.

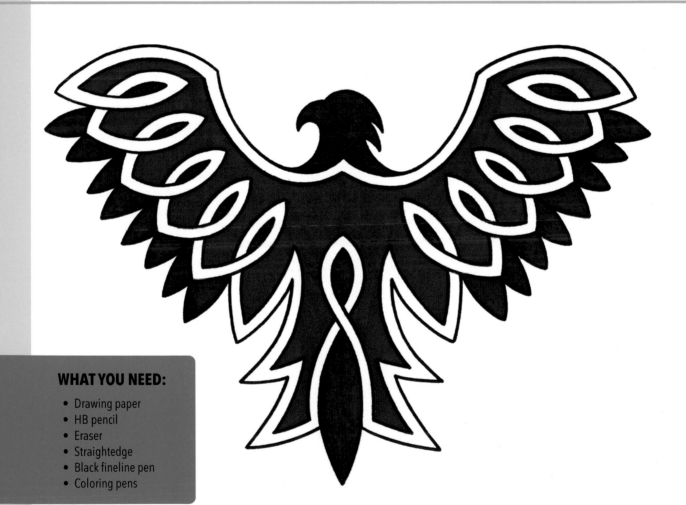

WHAT YOU NEED:
- Drawing paper
- HB pencil
- Eraser
- Straightedge
- Black fineline pen
- Coloring pens

Make sure the spacing between the lines is consistent.

1 Using an HB pencil, lightly sketch an upside-down triangle and then split it into two halves by drawing a vertical line through the center.

Starting approximately a quarter of the distance from the top of the vertical line, draw two side-by-side curves that angle up toward the top left side of the triangle.

Draw two more arcs starting from the ends of the first curves that angle above the top horizontal line and then back down to the left side of the triangle.

2 Mark out five points along the left edge of the triangle. Draw a curve from each point and then draw a second curve that mirrors the first curve. Repeat until you have created five small ellipses that run through the center of the left wing. (Don't worry if your ellipses aren't perfect or if the spacing between them isn't accurate; what's important is that you leave enough room to double up the lines.)

3 Using your straightedge, draw guidelines from your five starting points on the left side that stretch across the image and line up with the left side. (These will help you with accuracy and symmetry.)

Double up the lines on the left side, making sure the spacing is consistent throughout.

Draw matching curves on the right side that mirror the curves on the left and then begin drawing the ellipses on the right side.

4 Complete the ellipses on the right side to complete the wing feathers.

Determine the width of the tail by drawing an upward curve from the bottom point of each wing to the guideline that lines up with the fifth feather. Draw a downward curve on the left side that extends slightly beyond the triangle's edge and then add a slight curve back into the triangle to create a cone-like shape. Do this again below the first cone, making the next one shorter. Use your straightedge to draw guidelines to the opposite side and then repeat the process on the opposite side.

5 Double up the tail feather lines and then draw two wavy lines in the center to create a small ellipse in the midsection of the body. Once you're happy with the pattern, double up the lines and draw the eagle's head. The top of the head should fall just below the top edge of the triangle and be centered on the vertical line.

6 Add feather details on the underside of the wings.

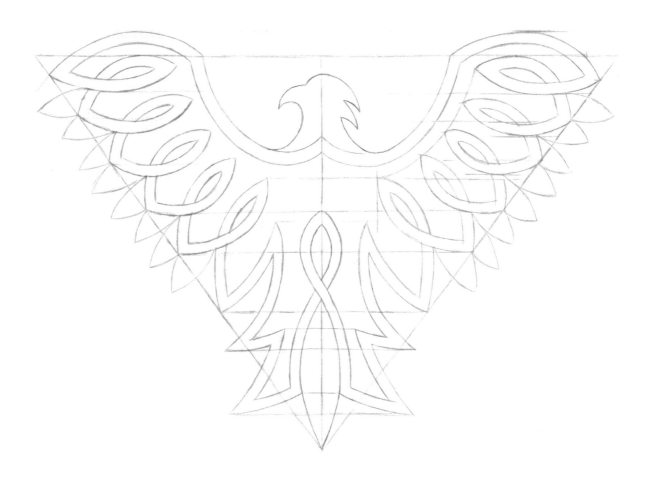

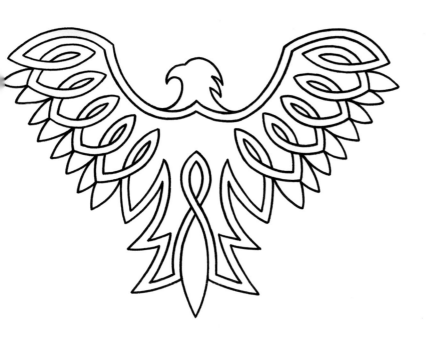

7 Once you're happy with the layout, trace the design with a black fineline pen and then erase all guidelines.

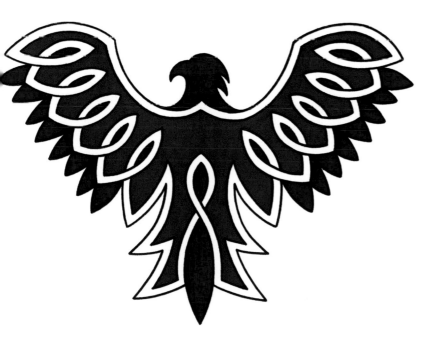

8 Color in the design with coloring pens, using whatever colors you prefer.

LEVEL ● ● ● ○ NUMBER OF STEPS 8

Dragons can symbolize different things to each of us, but from an art and design perspective, they're always fun to draw. These mythical creatures come in all different shapes and sizes, so there really is no right or wrong way to draw one—they can be wingless or have short or long tails; they may breathe fire or have smooth or scaly skin.

WHAT YOU NEED:

- Drawing paper
- HB pencil
- Eraser
- Black fineline pen
- Black marker pen

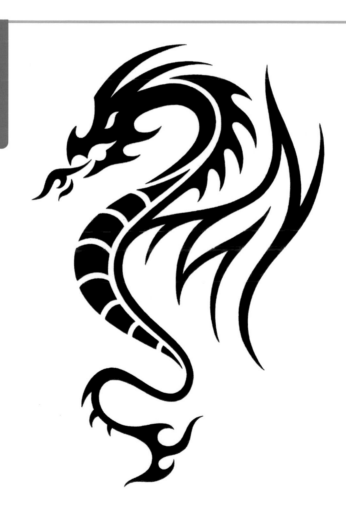

1 Using an HB pencil, lightly sketch an upside-down "U" shape that points up and toward the right.

Next, add a wavy line that swings down toward the bottom right, but sharply curves toward the left at the end.

2 Draw a second wavy line that flows in the same direction as the first line. (This line will determine the width of the body and neck, so make sure the spacing is wider in the central area.)

Mark out a rectangular shape for the head and then outline the face with some spiky curves.

3 Add lines inside the body shape that divide the neck and body into two parts and then draw a sweeping arc from the top of the neck down to the bottom of the neck.

Draw in some horns, an eye, and a mouth.

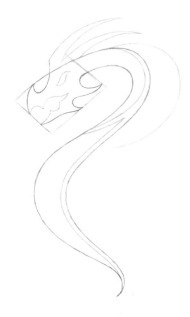

The spikes on the neck should follow the path of the arc in a downward motion.

4 Draw some spikes inside the sweeping arc on the right side of the neck and then draw curved lines to divide the body area into squared sections.

Mark out some guidelines for the wing.

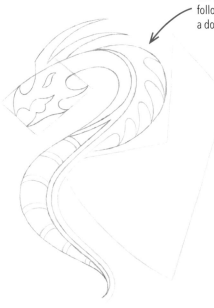

5 Draw some spiky curved lines for the wing that taper on the ends, making sure to keep the thickness of the pattern consistent throughout.

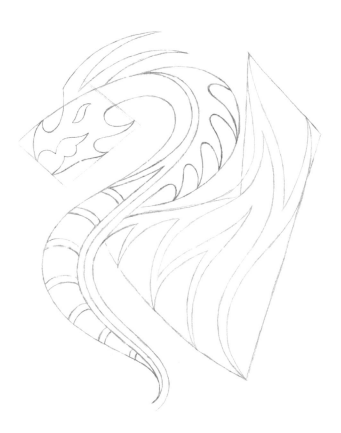

6 Extend the tail by drawing a wavy "S" shape. Draw some flamelike spikes on the right side at the bottom of the tail and then add a few small spikes on the left side of the tail. Draw in some flames that start inside the mouth and point toward the bottom left.

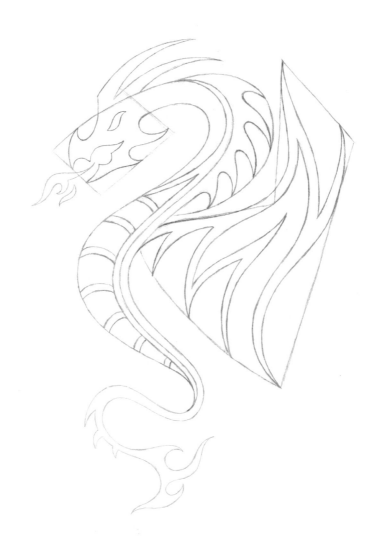

7 Trace around the image with a black fineline pen and then erase the guidelines.

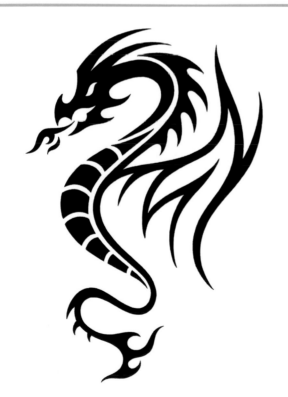

8 Use a black marker pen to fill in the image.

LEVEL ● ● ● ● NUMBER OF STEPS 10

In Japanese and Chinese cultures, the koi fish is a symbol of determination and strength. Koi have the ability to swim against very strong currents, and there's a Chinese legend that says a koi swam all the way to the top of a mountain and then turned into a dragon. From a design aspect, the flows and curves of a koi are challenging but very rewarding to draw.

WHAT YOU NEED:
- Drawing paper
- HB pencil
- Eraser
- Black fineline pen
- Coloring pencils

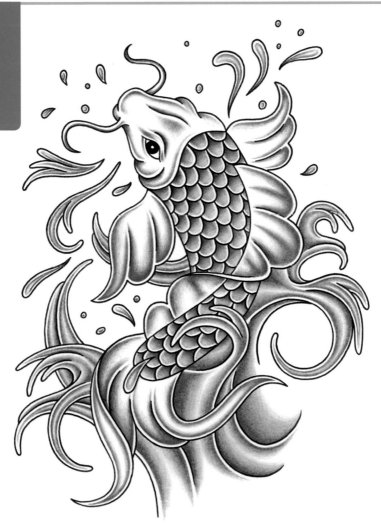

1 Using an HB pencil, lightly sketch a long curve on the right side that falls downward and then swings back to the left. Draw a second curve to the left that tapers toward the bottom of the first curve.

Connect the two curves at the very top with a diagonal line to create a curved cone shape.

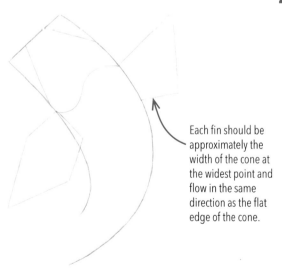

Each fin should be approximately the width of the cone at the widest point and flow in the same direction as the flat edge of the cone.

2 Mark out the head and two fins. Draw two diagonal lines inside the top of the cone shape. (These lines should be evenly spaced from the flat edge and then fall on either side of the curved cone shape.) Draw a wavy line across the width of the cone that follows the same direction as the flat edge.

From the ends of this wavy line, mark out angular areas for the fins.

3 Draw a curved line inside the cone and from the bottom left side that swings up toward the right side and stops just past the right fin. Next, draw another curve from this point that swings out to the right and bends back into the cone, falling onto the lower left side of the cone to create a backward "S" shape. Round off the end of the cone before moving on to the tail. Draw a stretched "S" shape for the left side of the tail that stretches downward and toward the left and then draw a wavy line on the right side that drops down before sharply bending upward and falling to the right.

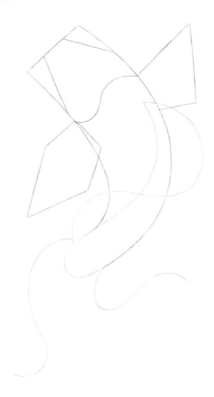

4 With the basic koi fish layout in place, you can start adding details. Begin by drawing curved lines inside the fins and then drawing some wavy lines inside the tail that should all flow along the same path as the tail's outside edges. Draw the outline of the head inside the guidelines.

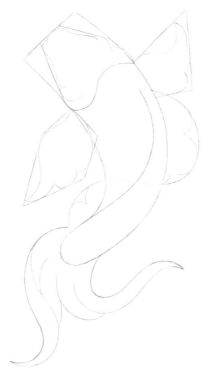

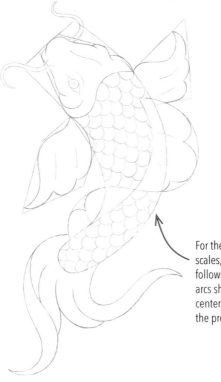

5 Give the fish some barbels (feelers) on either side of the mouth by drawing thin wavy curved lines that taper at the ends.

Draw an almost human-like eye with a line across the top for the brow. Mark out some curved lines on the fins, and add a wavy line across the top of the head for extra definition.

Add scales to the body by drawing upside-down arcs in rows.

For the second row of scales, and every row that follows, the ends of the arcs should touch the centers of the arcs in the previous rows.

6 Once you're happy with the fish, add some splashes of water by simply drawing some flicks and curls that taper at the ends.

7 Continue drawing more splashes on the left side and then draw a variety of different-sized splashes and spots of water in between the splashes.

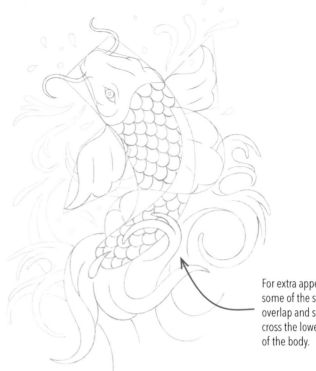

For extra appeal, make some of the splashes overlap and slightly cross the lower side of the body.

8 Outline the entire image with a black fineline pen and then erase any guidelines.

Use the HB pencil to shade in the scales, shading dark to light from the inside out and leaving a white edge around the outside of each scale for extra appeal.

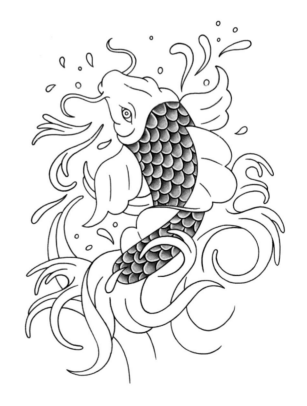

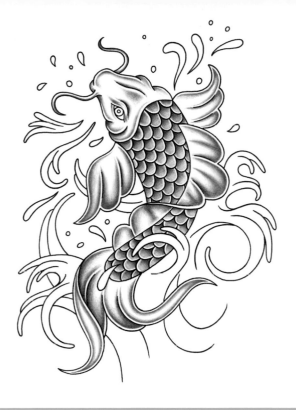

9 Shade the rest of the koi fish while leaving a white edge around the outside edges. (This effect will really make the image stand out.)

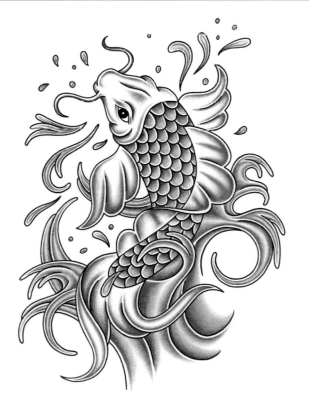

10 Using the black fineline pen, fill in the iris of the eye.

Use a blue coloring pencil to shade the water splashes, leaving a white edge around the outside edges of the splashes. Finish by applying a lighter blue coloring pencil for the white space inside the splashes.

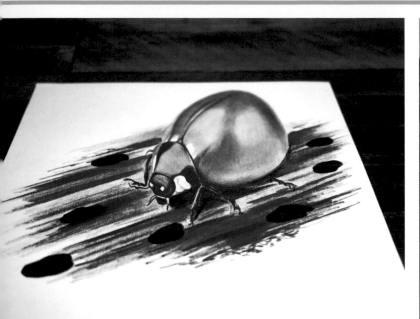

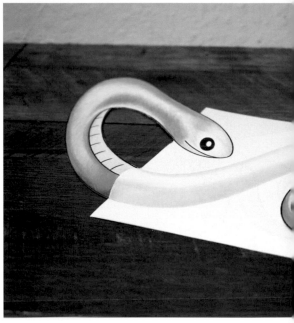

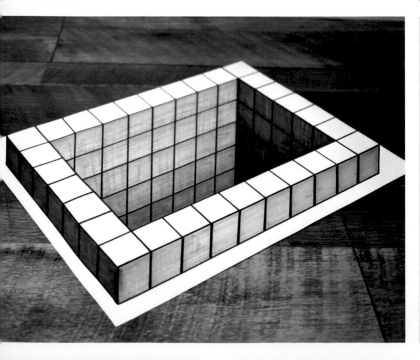

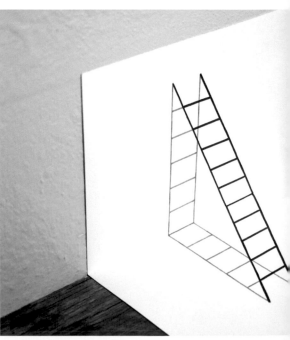

3D
TRICK ART

Optical illusions are not only fun to look at, they're also fun to create. They can help you see things from a different perspective and provide challenges that help develop your thinking and boost your drawing skills. Many people find optical illusion drawings very impressive, so it's fun to create them and show off your skills to others. In this chapter, I've created a variety of different subjects that feature anamorphic art for all skill levels.

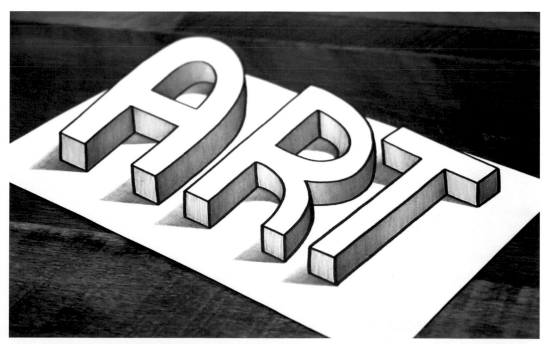

3D GHOST

LEVEL ●○○○ NUMBER OF STEPS 10

Ghosts are subjects of fear for some and fascination for others. Whether you believe in them or not, they factor into popular culture a lot and make good subjects when you're learning to draw. This project makes the ghost three-dimensional, which is a useful drawing skill to learn.

WHAT YOU NEED:

- Drawing paper
- HB pencil
- Eraser
- Straightedge
- Black marker pen
- Scissors

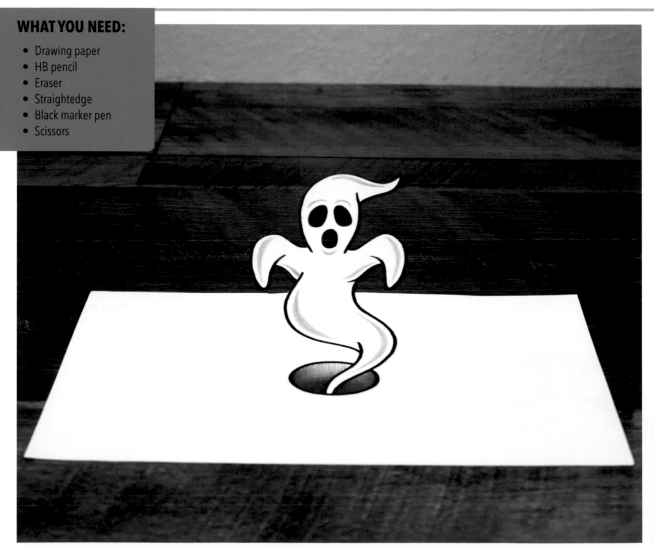

1 Using an HB pencil, lightly sketch a vertical rectangle. (The height of the rectangle should be approximately three times the width.)

Split the rectangle into two halves by drawing a horizontal line through the center.

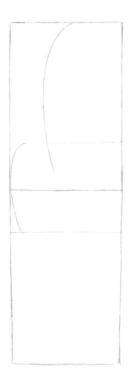

2 Draw two horizontal guidelines at equal distances above and below the center line. (These guidelines will help line up the curves on the opposite side.)

Draw a slight curve from the top center of the rectangle that falls just above the center line. Draw a shorter slight curve that takes a similar path but touches the left outside edge of the rectangle.

3 Draw another horizontal guideline about one fifth of the way down the rectangle that splits the bottom section of the rectangle into two halves.

Draw curves to define the top of the head and the left side of the arm and then draw a curved line for the left side of the body that meets the newest horizontal guideline.

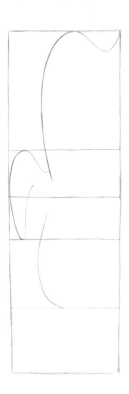

4 Draw a curved line for the right side of the head and then draw a wavy line that goes up to the top right corner. Draw a slight wavy line for the underside of the arm.

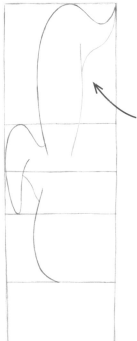

Try to position the head in the center of the guidelines.

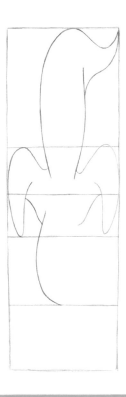

5 Draw the right arm, making it just slightly higher than the one on the left.

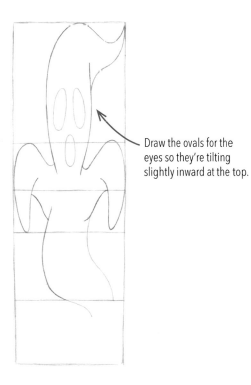

Draw the ovals for the eyes so they're tilting slightly inward at the top.

6 Draw a wavy line for the right side of the body and then extend the left side slightly by drawing a short curve that points toward the bottom right.

Draw two ovals for the eyes and a slightly smaller oval for the mouth.

7 Draw two wavy lines at the bottom that swing to the left and then taper together at the end. (The shape should be similar to that of a tornado.)

Draw an oval around the outside of the bottom shape.

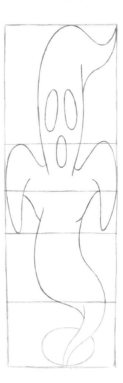

8 Using the black marker pen, trace over the image and then erase all guidelines.

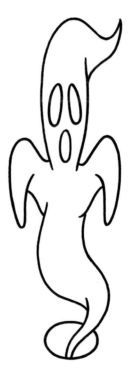

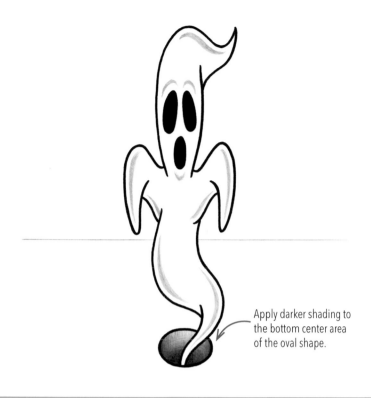

9 Using the HB pencil, add a little shading around the outside edges of the ghost and then apply some shading to the oval shape at the bottom.

Using the HB pencil and straightedge, draw a line behind the ghost that falls just below the bottoms of the arms.

Use the black marker pen to fill in the eyes and mouth.

Apply darker shading to the bottom center area of the oval shape.

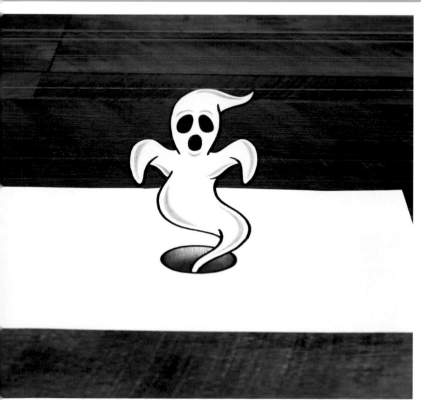

10 Using scissors, carefully cut along the horizontal line and then cut around the top of the ghost, cutting just outside the black marker line.

Lay the drawing on a flat surface, stand back, and admire the illusion!

LEVEL ●○○○ NUMBER OF STEPS 6

3D projects are some of the most enjoyable to draw. And although they do require a little work, the responses you'll get from others will make it all worthwhile! This 3D ladder is one of the simpler 3D trick drawings to accomplish. The eye is fooled into seeing a ladder propped up against a wall, but it's all done using some angled lines and a little folding.

WHAT YOU NEED:

- Drawing paper
- Black marker pen
- Gray marker pen
- Ruler

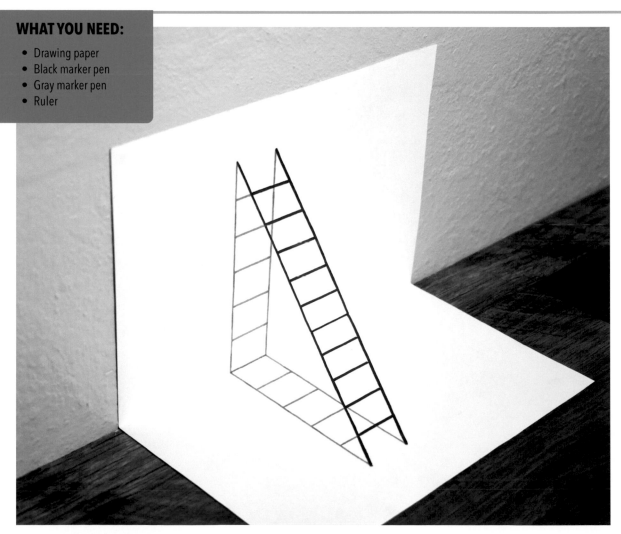

1 Using a gray marker pen and a ruler, draw two parallel vertical lines. Both lines should be 8½ inches (22cm) long and spaced 1 inch (2.5cm) apart. (If you're confident enough, try drawing the lines freehand and just use the ruler for measuring.)

2 Using the gray marker pen and the ruler, divide the space between the two vertical lines into 11 equal-sized spaces by drawing 10 horizontal lines. The spacing between the lines should be ¾ inch (2cm).

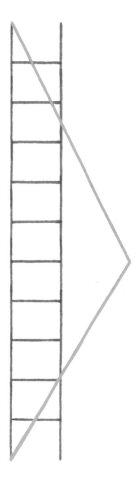

3 Count six lines down and make a mark 1⅜ inches (3.5cm) away from the right outside edge of the ladder. Next, use a black marker pen to draw a diagonal line from this point to each end of the left vertical line.

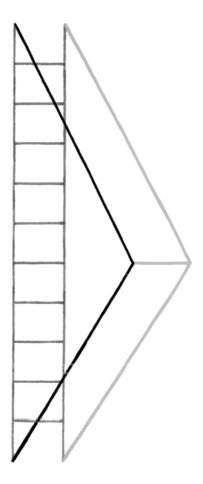

4 Using the black marker pen, mark 1³⁄₁₆ inches (3cm) to the right of the
 corner where the two diagonal lines meet and then draw a diagonal
 line to each end of the right vertical line in the ladder. Join the two
 angled lines with a horizontal line.

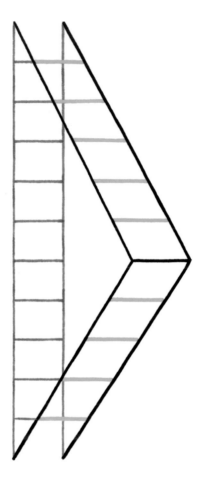

5 Using the black marker pen and ruler, draw horizontal lines that align
 with the gray lines.

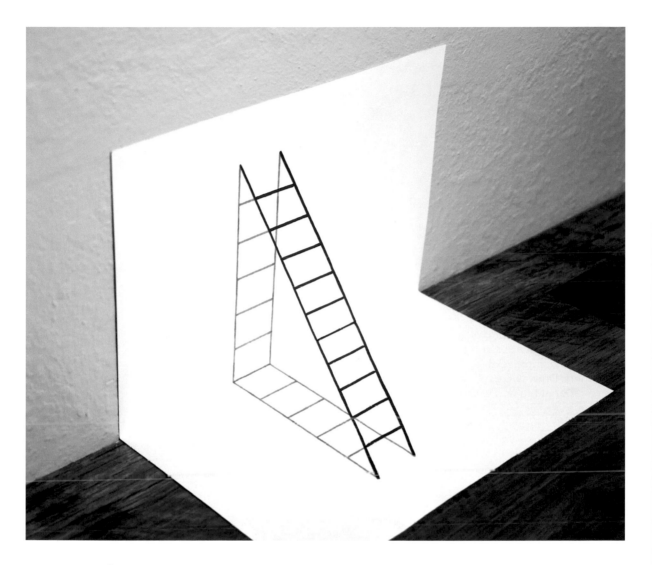

6 Count six lines down and fold the paper at this point. (To make a clean fold, place the ruler across the paper and press down on the ruler while pulling the top side of the paper toward you.)

Place the folded drawing up against a wall, and see the magic appear!

LEVEL ●●○○ NUMBER OF STEPS 10

Spiderwebs have been featured prominently in folklore and myth and make people think of weaving, network, and spinning. It's not hard to understand why even modern humans can look at a web with its delicate intricacy and be astounded at how it comes about. This 3D web is a simple but cool representation of the traditional spiderweb.

WHAT YOU NEED:

- Drawing paper
- HB pencil
- Eraser
- Black marker pen
- Gray marker pen

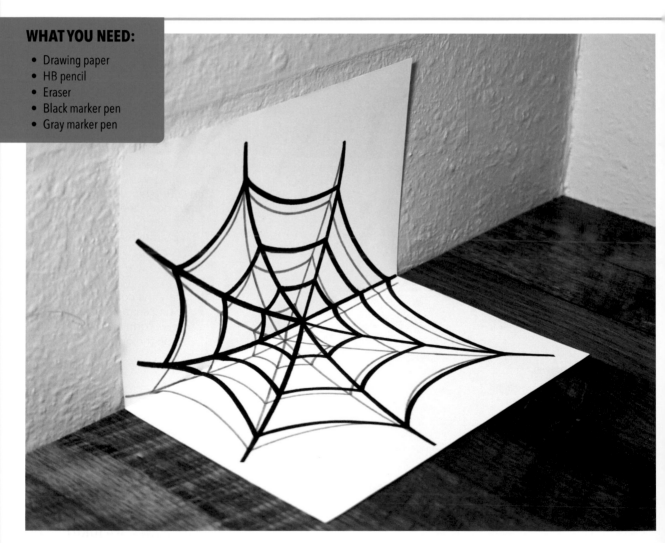

1 Begin by folding the paper in half. Using an HB pencil, draw a line along the fold that swings up toward the left side of the paper and above the fold.

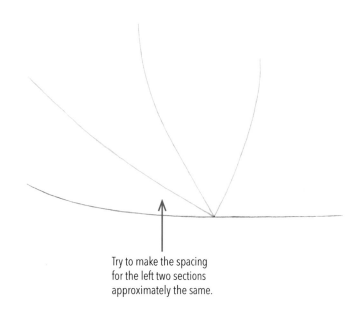

2 Starting from the same point on the fold line, draw three upward curves to create four sections.

Try to make the spacing for the left two sections approximately the same.

3 Draw three more curves below the fold line to create four more sections. (They don't have to be exact, but try to make the spacing between all of these sections similar in width.)

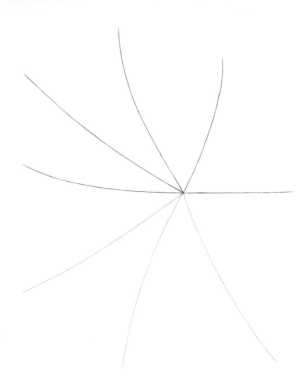

4 Draw arcs inside the top curves, making the curves of the arcs less pronounced as you move from left to right.

The left arc should be the most pronounced.

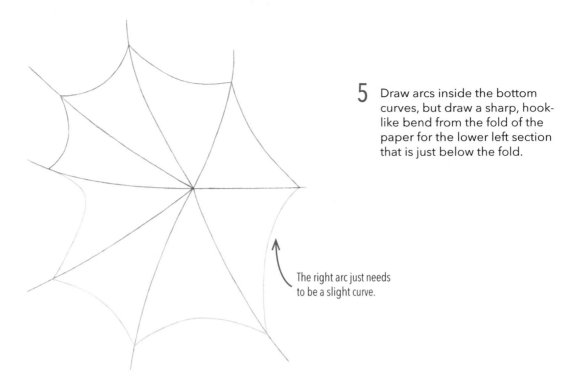

5 Draw arcs inside the bottom curves, but draw a sharp, hook-like bend from the fold of the paper for the lower left section that is just below the fold.

The right arc just needs to be a slight curve.

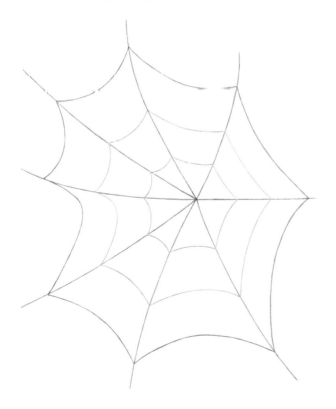

6 Draw two more sets of arcs in the center of the web. These lines should follow the same paths as the outside lines.

7 Using a black marker pen, trace over the pencil lines. (Try to make these lines thick so they stand out more.)

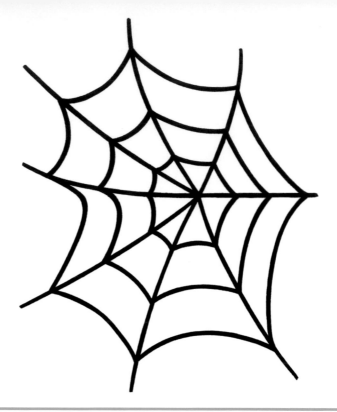

8 Using a gray marker pen, add a shadow underneath each of the original curved lines. These lines should all meet at a point just below the center fold and to the left of the original web center.

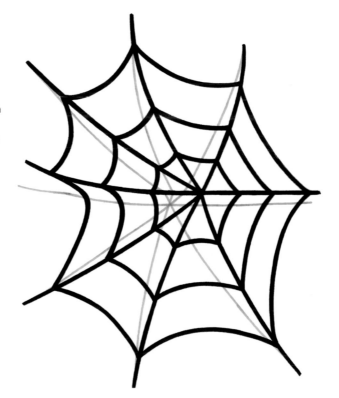

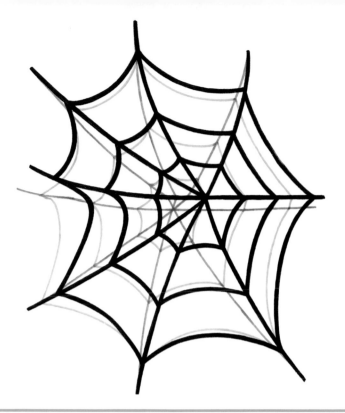

9 Complete the shadow by using the gray marker pen to draw lines below the arcs.

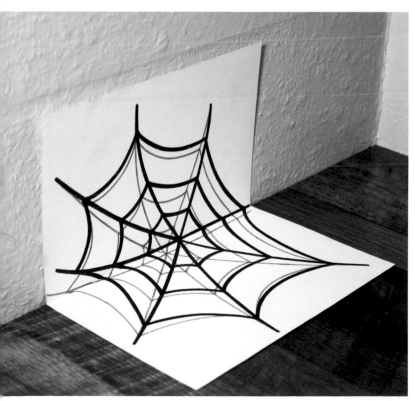

10 Place the drawing against a wall and floor, with the fold of the paper resting where the floor and wall meet.

Stand back and enjoy the illusion!

SNAKE UNDER PAPER

LEVEL ● ● ○ ○ NUMBER OF STEPS 10

The smooth green snake is a nonvenomous species that can be found in North America and is most noticeable because of its smooth skin and vibrant green color. These same characteristics look especially good here when used in an optical trick, where the snake appears to be hidden underneath a sheet of paper.

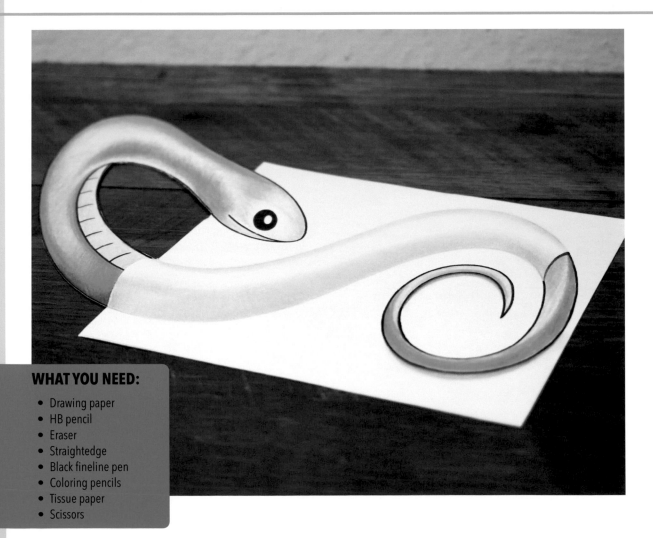

WHAT YOU NEED:
- Drawing paper
- HB pencil
- Eraser
- Straightedge
- Black fineline pen
- Coloring pencils
- Tissue paper
- Scissors

1 Using an HB pencil, lightly sketch a curved line that swings into a hook and points up toward the right before turning sharply back down toward the left.

2 From the bottom left of the curved line, draw a wavy line that snakes into a spiral toward the bottom.

3 Double up the wavy line by drawing another one next to it to create an elongated "S" shape. (The spiral segment at the bottom will be the end of the tail and should be narrowest part, and the center portion should be the widest part.)

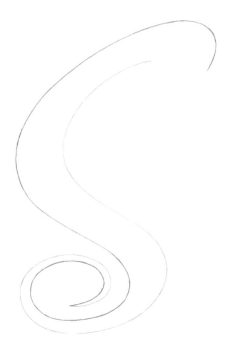

4 Draw an arc that starts inside the snake's body that points toward the top right before swinging sharply back toward the bottom left.

Draw a curved line for the snake's head, and continue the curve until it joins up with the end of the hook from step 1. Draw a curved line for the mouth and then draw an oval shape with a smaller oval inside for the eye.

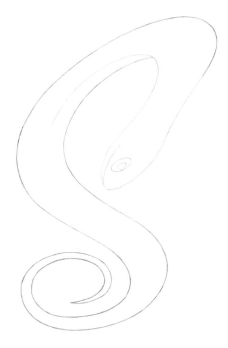

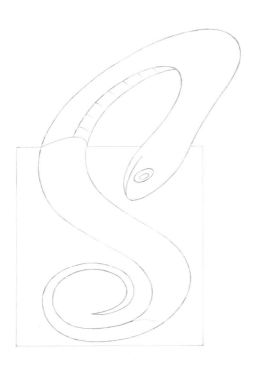

5 Draw a hook across the width of the snake's body, just above the widest point on the left side. Next, using a straightedge, draw a rectangle along the outside of the snake that meets up with the hook.

Draw a slight curve across the width of the snake's tail on the bottom right. Add parallel lines to the upper body to show the snake's underside.

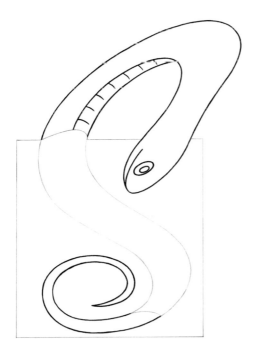

6 Using a black fineline pen, outline the snake above the hook and then outline the snake's tail below the slight curve on the tail.

7 Using a green coloring pencil, add some shading to the darkest areas of the snake's body.

8 Using a lighter green or yellow coloring pencil, shade in the lightest areas, but leave some white space around the eye and across the central part of the snake's body on the top right. Use the black fineline pen to fill in the iris of the eye.

9 Using the HB pencil, shade the area of the snake that isn't outlined with the pen. Begin by shading half of the width on the left side and then adding just a little shading to the right side.

Add a little shading to the left side of the tail to create a shadow.

Use the tissue paper to lightly rub the pencil marks to create a smooth finish.

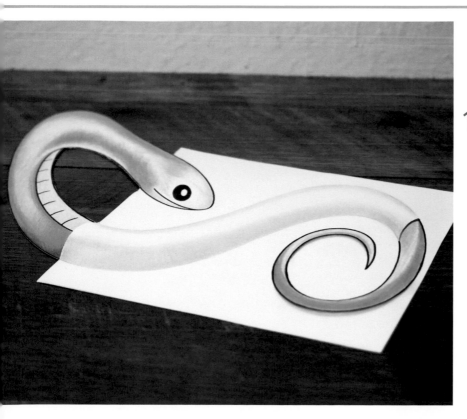

10 Using the scissors, carefully cut around the drawing above the top portion of the snake's body and then cut the areas around the rectangular guidelines.

Place the drawing on a flat surface and then stand back to see the illusion!

3D LADYBUG

LEVEL ● ● ● ○ NUMBER OF STEPS 9

Ladybugs are highly beneficial insects in gardens; they eat the aphids that would otherwise eat their way through fruits and vegetables if left alone. They're also very nice to look at with their bright red, yellow, or orange colors and pleasing spots. This stylized ladybug has had her spots knocked off in a very interesting and artistic way.

WHAT YOU NEED:
- Drawing paper
- HB pencil
- Eraser
- Coloring pencils

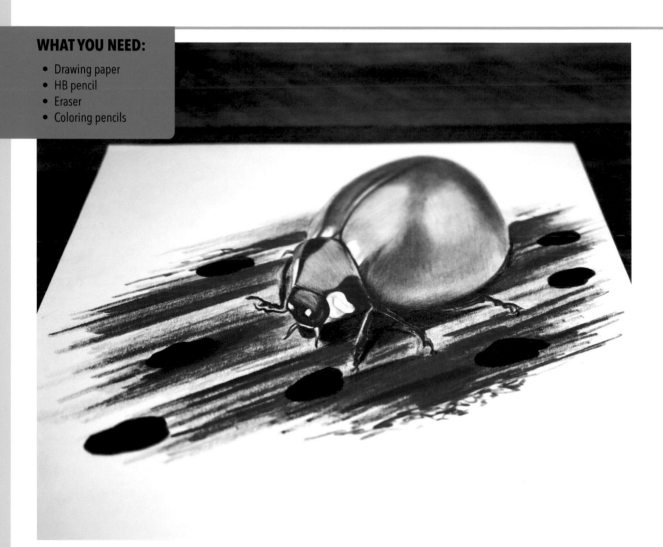

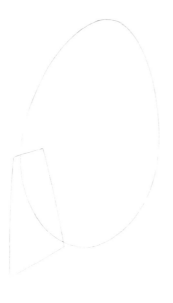

1 Using an HB pencil, lightly sketch an egg shape that leans slightly to the right.

Draw a four-sided cone shape that sits just on the inside of the bottom left of the egg shape and extends out into a point. (The height of the cone shape should be approximately three times the width.)

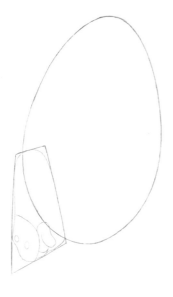

2 Outline the ladybug's face by drawing a long curve that flows from the left side up across the top and then draw a nose-like shape with small ovals that look like nostrils.

Draw a couple of small curves to the right side of the nose that almost look like two overlapping ovals, but with one bending slightly to the right.

3 Draw the top portions of five legs. The two legs on the bottom right should look like an upside-down "V" shape, and the one on the far right should bend and flow in a similar path as the body. Draw a small hook for the top left leg, and draw a leg just below that bends into the left side of the nose.

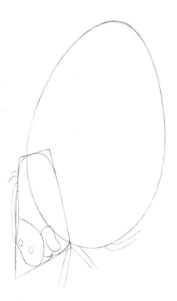

4 Draw the bottom parts of the legs. Try to make these quite jagged and shorter than the top portions of the legs.

Ladybugs have six legs, but the back leg on the left side will be hidden behind the body.

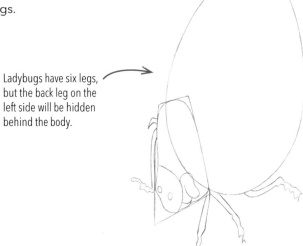

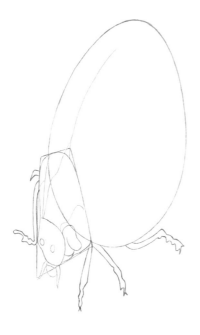

5 For the antennae, draw a small upside-down arc below the nose with two slender curve shapes on each side that taper at the end.

Mark out a bumpy line from the top left of the nose up through the central portion of the head.

Draw a line just to the left that flows with the outside edge and then draw a wavy line across the lower right side of the head. Draw a curved line inside the left side of the body that flows from the center of the head.

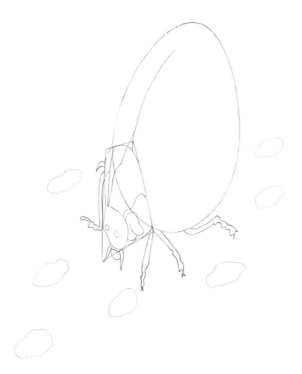

6 Draw seven jagged oval shapes for the spots that all flow in the same direction.

7 Use the HB pencil to begin adding some shading, concentrating on the darkest areas first. Shade in the spots.

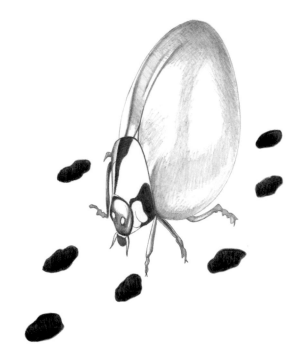

8 Continue with the shading until you're happy with the result.

Next, use a red coloring pencil to shade between the spots.

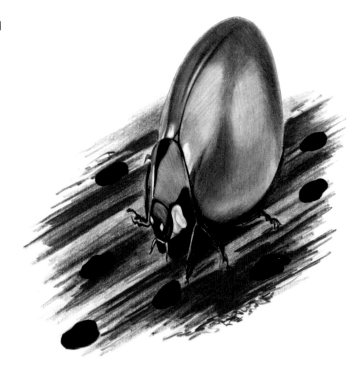

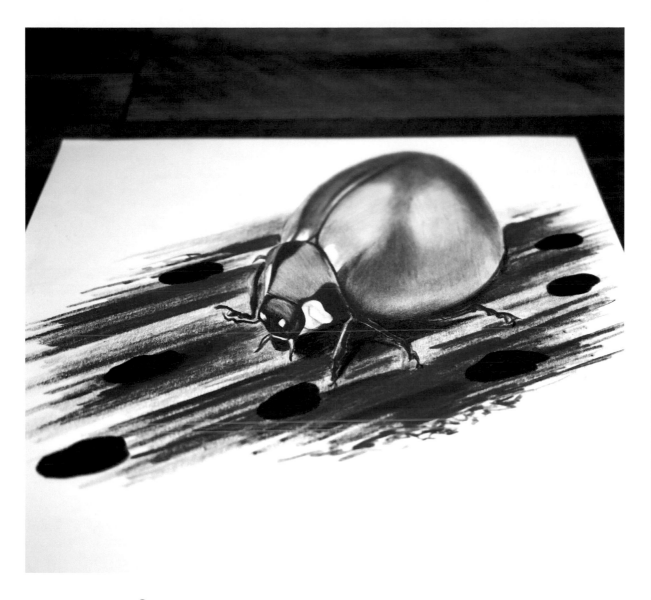

9 Lay the drawing on a flat surface. Rotate the drawing until the perspective is correct and then step back to see the illusion!

LEVEL ● ● ● ○ NUMBER OF STEPS 8

Letters are generally thought of for their function; the first things we learn how to draw are letters, and basic letter writing skills are satisfied as soon as you can learn to write them neatly. But letters can be elevated to art in many ways, including adding a 3D touch to their forms. This extra fun project makes a 3D letter look like it's sinking into the paper.

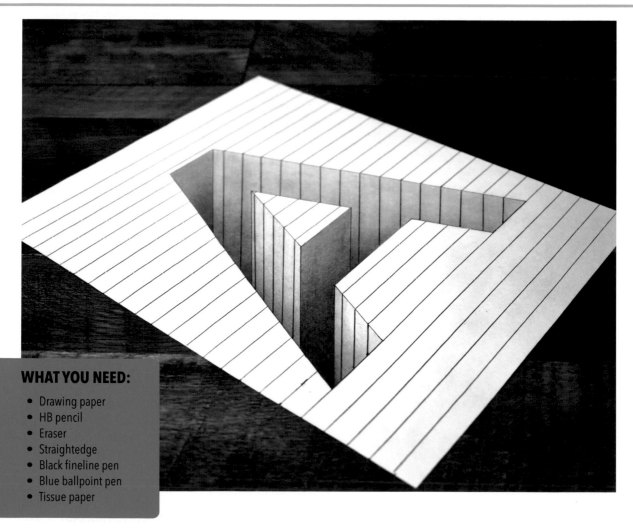

WHAT YOU NEED:

- Drawing paper
- HB pencil
- Eraser
- Straightedge
- Black fineline pen
- Blue ballpoint pen
- Tissue paper

1 Using an HB pencil and a straightedge, lightly draw a triangle shape by drawing a vertical line and then adding a horizontal line across the bottom.

Draw diagonal lines from each end of the horizontal line to the top end of the vertical line.

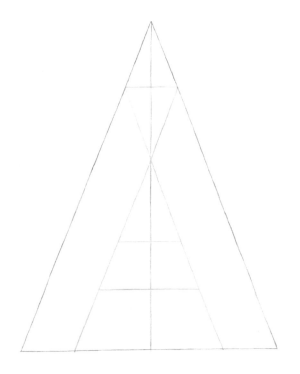

2 Draw two diagonal lines on the inside of each diagonal line that are parallel with the outside diagonal lines. Draw a horizontal line at the top that connects the end points of the diagonal lines.

Draw two more horizontal lines toward the bottom to form the crossbar of the "A."

3 Using the black fineline pen, outline the letter and then erase all guidelines.

Leave a wider space at the top to make the drawing look like it's created on notebook paper.

4 Using the straightedge and a blue ballpoint pen, draw evenly spaced lines behind the letter.

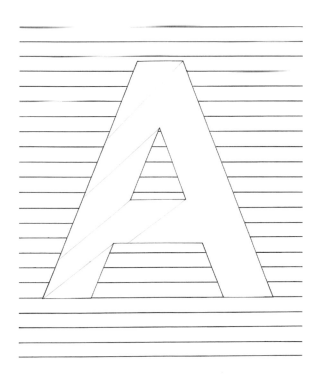

5 Using the straightedge and the HB pencil, draw five diagonal lines that start from the inside corners of the letter and angle down to the left. (To better see where the lines are lining up, try looking at the image at an angle with one eye closed.)

6 Using the straightedge and the blue ballpoint pen, draw diagonal lines from the points where the blue lines meet the outside right edge of the letter. The angles of the blue lines should be the same as the black lines that were drawn in pencil in step 5.

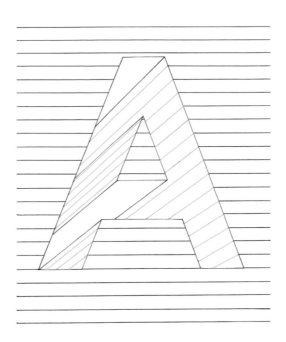

7 Using the HB pencil, shade in the image, leaving the areas that extend from the inside left edges of the letter the lightest, making the right side of the letter a slightly darker shade, and shading the remaining areas on the left side of the letter the darkest shade. Use a piece of tissue paper to gently smudge the pencil lines and make the shading more smooth.

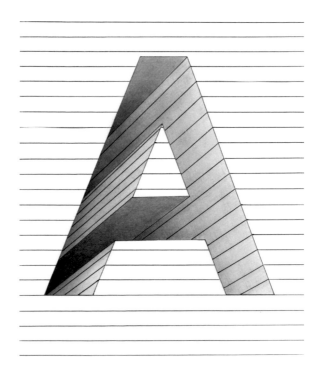

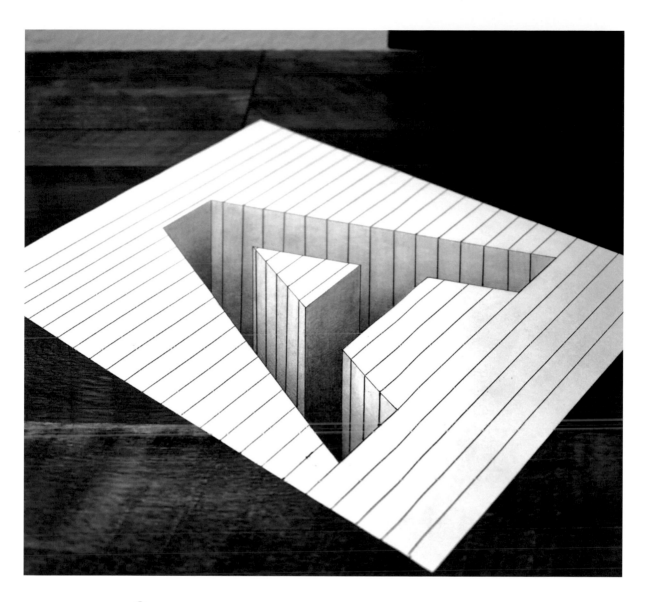

8 Place the paper on a flat surface and slowly turn the paper until the image lines up, and the letter appears to sink below the surface!

LEVEL ● ● ● ○ NUMBER OF STEPS 9

3D art manipulates the eye in order to make a drawing look like it has width, height, and depth. This can be achieved using many different techniques. This drawing uses lines that trick the eye into seeing a hole in the paper that goes down and in. This is a really entertaining technique to learn to draw.

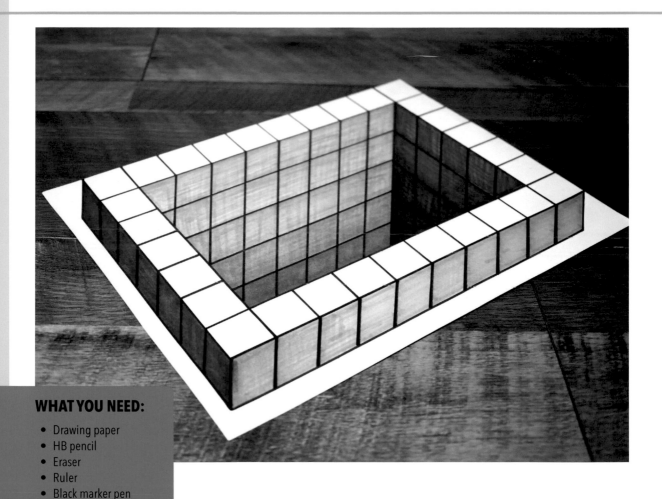

WHAT YOU NEED:
- Drawing paper
- HB pencil
- Eraser
- Ruler
- Black marker pen
- Gray marker pen

1 Using a ruler and an HB pencil, mark out a rectangle that is 7 inches (17.75cm) high and 10 inches (25.5cm) wide. (Use the top and right side edges of the drawing paper for two of the sides.) Make a mark at every 1 inch (2.5cm) inside the paper edges and along the lines.

2 Create a squared border inside the rectangle that is 1 inch (2.5cm) from the outside edges of the rectangle. Draw lines from the outside marks to the inside borders.

3 Using the ruler, draw a diagonal line from the top right inside corner to the bottom side of the border and then draw three short diagonal lines from the bottom right, top left, and bottom left corners that all run parallel with the diagonal line inside the rectangle. (For the illusion to work, it's important these lines are as parallel to each other as possible. If you take a step back and close one eye, you can use the other eye to help align the lines with a ruler.)

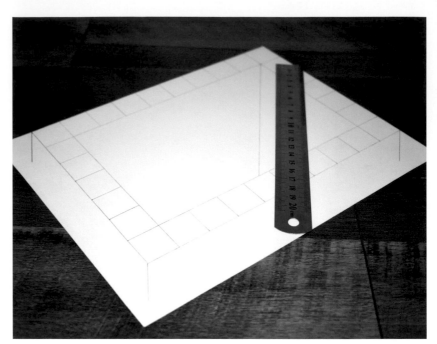

4 Connect the three short diagonal lines with lines that are parallel to the outside edges of the paper.

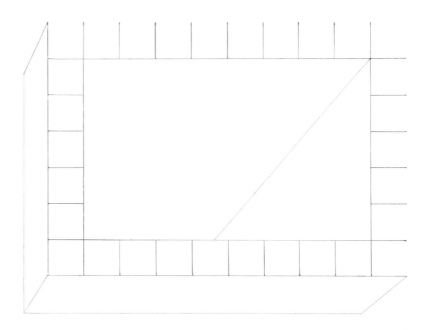

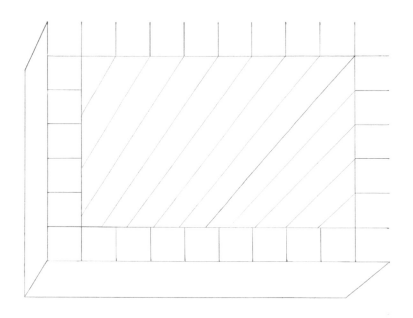

5 Draw diagonal lines from each of the marks on the top and right side borders. These lines should all gradually taper toward the bottom left of the rectangle.

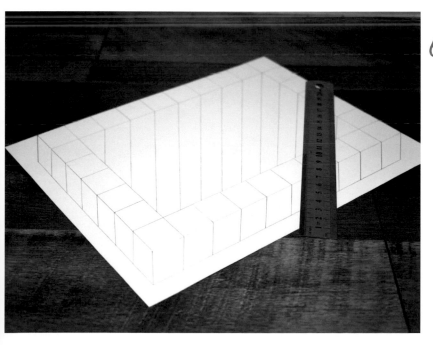

6 Use the ruler to draw diagonal lines from the marks on the inside edges of the rectangle to the outermost lines. (Again, these lines should all appear to be parallel to one another when looking at it from a certain angle.)

Take a step back, close one eye, and with a ruler, keep checking to make sure the lines are as parallel to each other as possible. (It's okay if the occasional line is off by a bit, the illusion will still work.)

7 Starting at the top, draw four sets of connecting horizontal and vertical lines on the inside of the rectangle to create five sections. Try to make the spacing between each horizontal line slightly narrower than the last as you draw the lines from top to bottom.

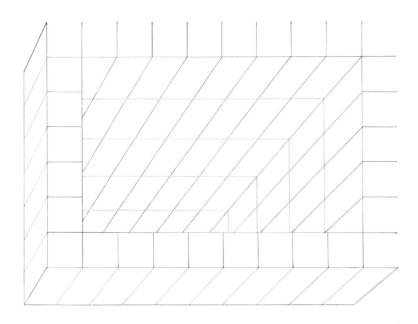

8 Using a black marker pen, trace over the image.

Shade in the angled sides with a gray marker, making the angled side on the left slightly darker than the angled side on the bottom.

Shade the inside of the rectangle with the gray marker pen, shading the side facing left slightly darker than the side facing the bottom.

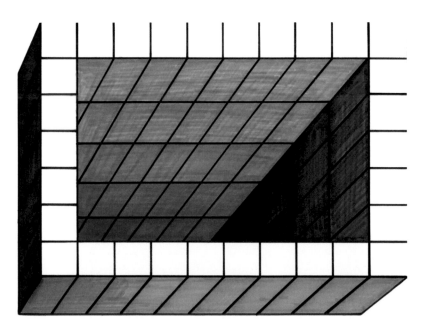

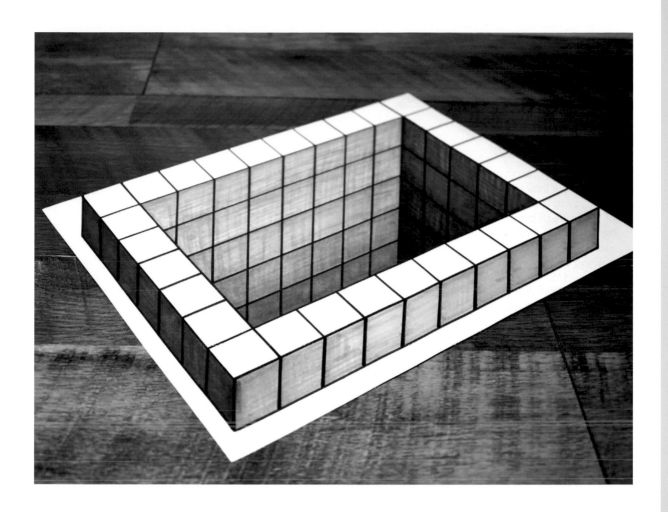

9 Place the drawing on a flat surface. Rotate the drawing
 until the perspective is correct and then stand back
 and enjoy the illusion!

LEVEL ● ● ● ● NUMBER OF STEPS 10

Words are used in almost every part of our lives. In the sea of words that we encounter all around us, the words that pop out the most are those that tend to capture our attention first. This neat, slightly advanced project transforms the word "art" into a three-dimensional artwork.

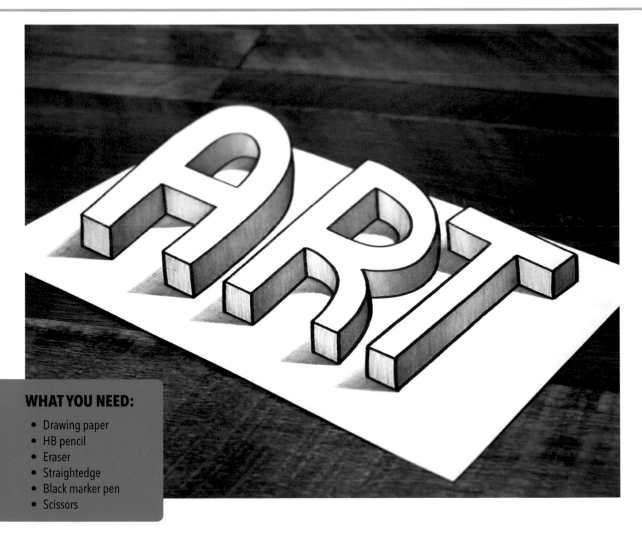

WHAT YOU NEED:

- Drawing paper
- HB pencil
- Eraser
- Straightedge
- Black marker pen
- Scissors

1 Using an HB pencil and a straightedge, draw an offset, vertical rectangle. Begin by drawing a vertical line for the left side and then a horizontal line for the bottom side, but draw diagonal lines for the top and right sides.

Draw another slight diagonal line about a third of the way down from the top and then draw a vertical line close to, but inside of, the original vertical line on the left.

2 Draw four more guidelines inside the offset rectangle, with each line tilting slightly more to the bottom right as you work from top to bottom.

The largest white spaces are where the letters will sit.

3 Draw a large curved line that looks like a hook, starting on the top line, approximately a third from the top right corner, and finishing slightly farther than halfway down the next guideline.

Draw another hook in the next space that begins to bend on the guideline a third of the way down before bending back in toward the middle of the space. Draw a connecting curve to the lower left corner of the space.

4 Draw four diagonal lines that start from the bottom left corners of the large spaces and go down to the guidelines. Draw diagonal curves to the guidelines from each existing curve inside the large spaces.

5 Define the letters "A" and "R" by drawing lines on the inside that follow the same paths as the outside lines, but try to make the spacing along the bends more narrow.

6 Complete the "A" and "R" by drawing diagonal lines and curves on the inside that follow the same paths as the outside lines.

7 Erase the inside guidelines and draw lines that follow the outside edge for the letter "T."

8 Complete the "T" by drawing lines around the outside that follow the same path. (Try to make the diagonals flow in the same direction as the diagonals in the "A" and "R.")

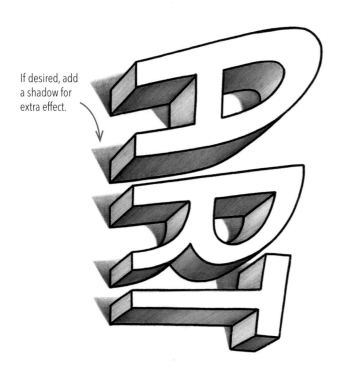

If desired, add a shadow for extra effect.

9 Using the black marker pen, trace over the letters and then use the HB pencil to shade in the sides. Make the shading for the sides that face left slightly lighter than the sides that face down.

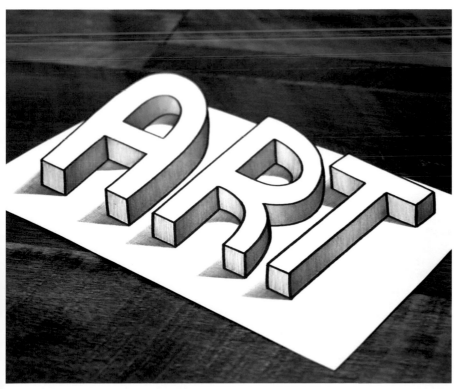

10 Using the scissors, carefully cut around the very tops of the letters.

Place the drawing on a flat surface and then turn the drawing until the perspective is correct.

Stand back and enjoy the illusion!

ANIMALS & INSECTS

Animals and insects have been drawing subjects ever since man first began drawing. These subjects are fascinating in their own rights and are always fun to draw, but wouldn't it be cool to show them in a different light? Your imagination and desire to draw new things can open the door to creating all kinds of fun stuff. In this chapter, I've covered a variety of interesting creatures that tackle design elements such as form, shading, and textures.

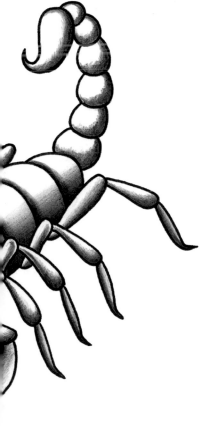

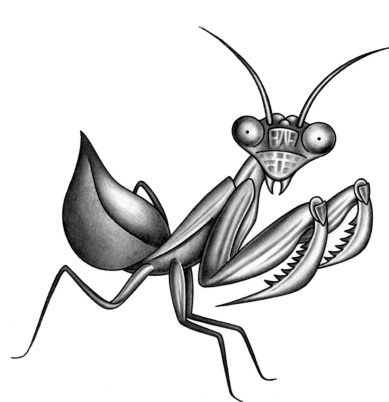

KOALA & ICE CREAM

LEVEL ●○○○ NUMBER OF STEPS 8

Koalas are small, cute animals from Australia. They're called "bears" due to their round ears and teddy bear–like appearance, but they are actually more closely related to marsupials like kangaroos and wombats. They normally climb trees in order to eat their favorite food, eucalyptus, but if they could, I'm sure they would happily climb an ice cream cone.

WHAT YOU NEED:

- Drawing paper
- HB pencil
- Eraser
- Black fineline pen
- Coloring pens

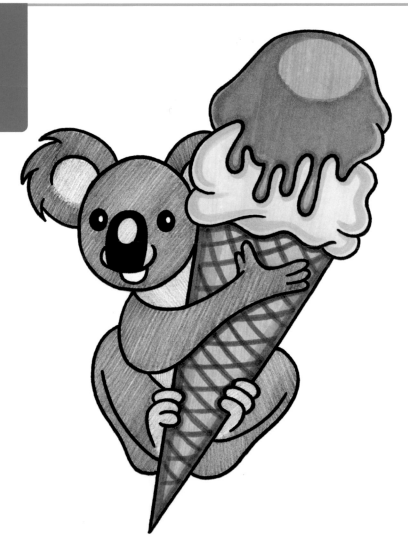

1 Using an HB pencil, lightly sketch an oval and then draw two smaller circular shapes at the top corners of the oval.

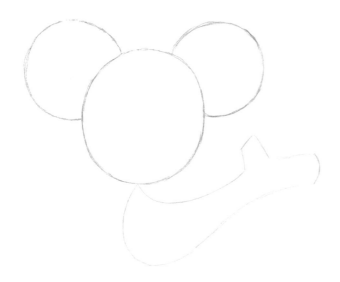

2 From the bottom center of the oval, draw two curved lines that swing up and out to the right. The bottom curve should stretch out the farthest. Draw guidelines for the hand.

3 From the left side of the arm, draw a curved line that swings out and then down toward the right and then draw a second line on the right side that swings up, out, and then back toward the arm. Join these two lines at the bottom with a slight diagonal line.

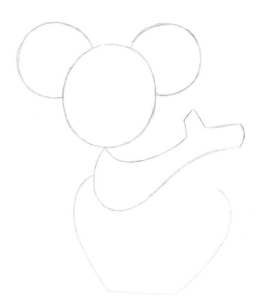

4 Draw two diagonal lines for the cone by drawing a diagonal line down from the bottom corner of the right ear to just past the slight diagonal line at the bottom. Draw a line up from this same point to just past the right side of the hand.

Draw the guidelines for the feet and legs by adding two flat ends for the feet, two curves on the left side that swing up for the left leg, and one curve on the right for the right leg.

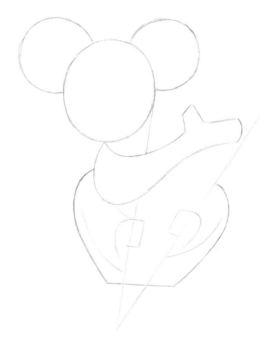

It's okay to erase parts of these guidelines now to avoid confusion later.

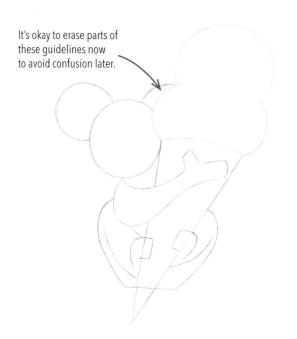

5 Draw curved lines for the ice cream. Begin by drawing an arc on the left side that faces toward the right and overlaps the head and ear and then draw a second arc on the right side that faces toward the left. Draw a large arc across the top.

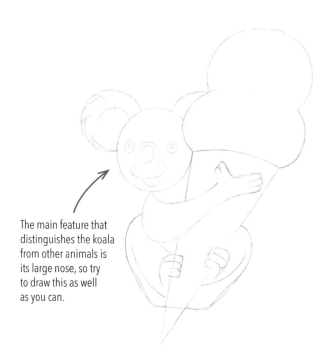

The main feature that distinguishes the koala from other animals is its large nose, so try to draw this as well as you can.

6 Draw some details for the ear by drawing three spiky shapes along the left edge and then drawing an arc inside the top center. Draw the nose, mouth, and eyes. Draw the fingers and toes, and give the bottom of the legs more curvature.

7 Give the ice cream more definition by drawing additional curves around the outside and then drawing some drips from the top scoop.

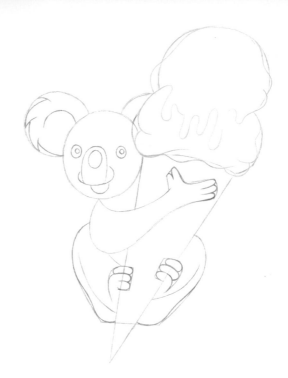

8 Using a black fineline pen, trace over the image and then erase all pencil marks.

Use the black fineline pen to fill in the irises of the eyes and the nose area.

Use the HB pencil to shade the koala, shading the insides of the ears and the neck, belly, and toes slightly lighter than the other areas.

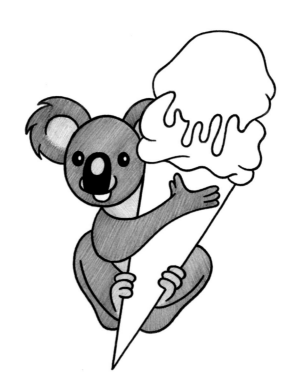

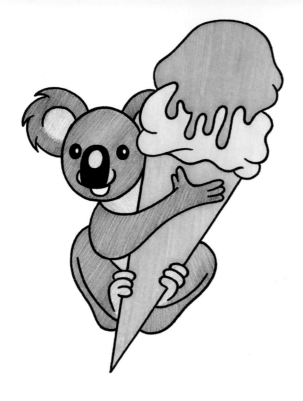

9 Using the coloring pens, color in the ice cream and ice cream cone.

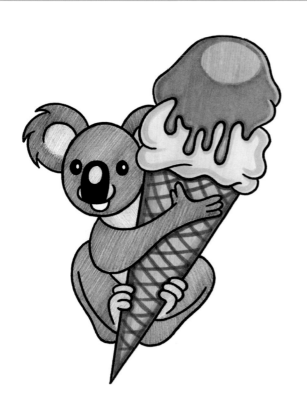

10 Using darker shades of the coloring pens, draw crossed lines on the cone and apply the same pen color along the edges of the cone.

With the same pens used for the ice cream, apply the same colors to make some of the areas darker. (Or you can just use darker shades of coloring pens.)

HOW TO DRAW A KOALA & ICE CREAM **143**

LEVEL ●●○○ NUMBER OF STEPS 10

Sea turtles are a favorite inhabitant of the ocean, and there are seven different species: leatherback, loggerhead, green, hawksbill, olive ridley, flatback, and Kemp's ridley. They are, unfortunately, endangered, but creating artwork featuring these beautiful creatures can help raise awareness about their endangered state.

WHAT YOU NEED:

- Drawing paper
- HB pencil
- 2B pencil
- Eraser
- Black fineline pen

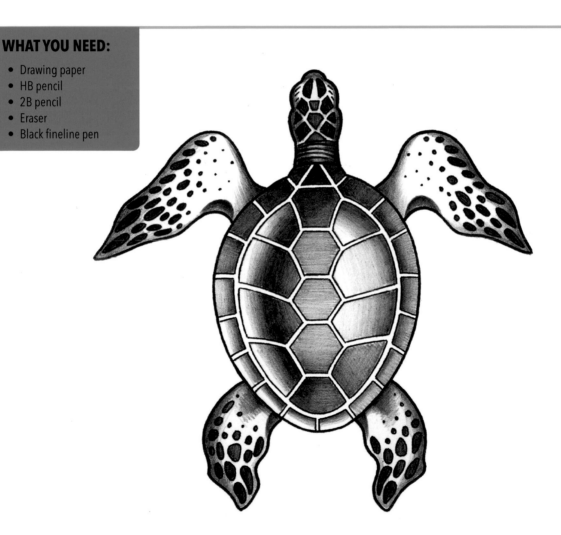

1 Using an HB pencil, lightly sketch an upside-down egg shape and then divide the shape into two halves by drawing a vertical line through the center.

2 Draw two sets of angled diagonal lines at the top corners of the upside-down egg shape that each resemble mountain peaks.

Draw two arcs that turn inward at the bottom of the upside-down egg shape.

3 With the guidelines in place, outline the flippers.

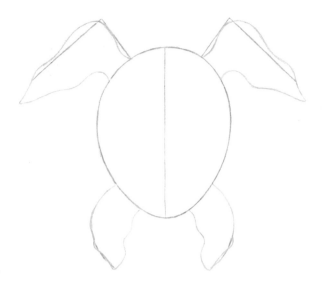

4 Draw the head and neck above the top center and then draw opposing curves inside the shell that follow the same path as the outside edges of the shell. (Try to make the spacing tighter at the bottom of the shell, and also leave a gap at the top of the shell so that it's not a continuous line.)

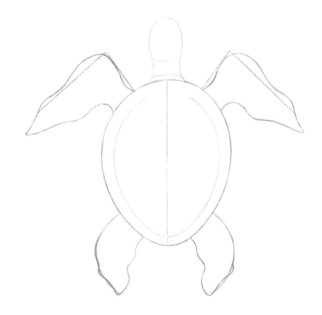

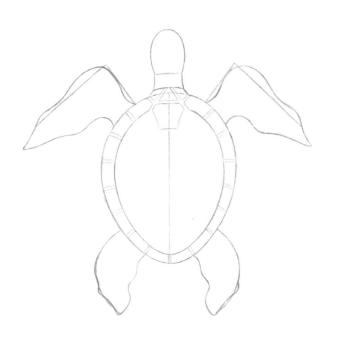

5 Draw a small triangle at the center top of the shell and then draw a parallel line on each side of the triangle.

Draw a hexagonal shape just beneath the triangle with short edges on the top sides. Break up the outside edge of the shell by adding double lines to create sections all the way around the perimeter.

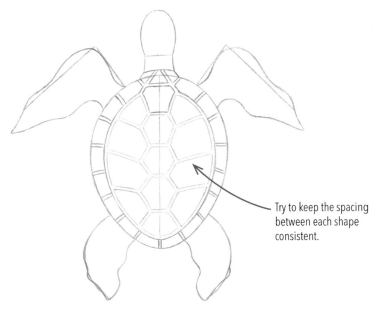

Try to keep the spacing between each shape consistent.

6 Draw three more hexagonal shapes down the center of the shell, ending with a shape at the bottom that is not quite hexagonal but with a rounded bottom.

Complete the contour of the shell by drawing shapes on each side that are uniform and mirror the shapes on the opposite side of the shell.

7 Add some detail to the flippers by drawing different-sized ovals and circles and then add some patterned shapes to the top of the head.

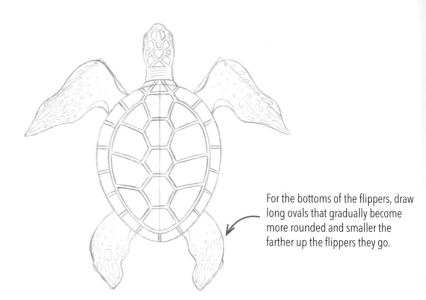

For the bottoms of the flippers, draw long ovals that gradually become more rounded and smaller the farther up the flippers they go.

8 Using a black fineline pen, trace over the image.

Using a 2B pencil, shade the spots on the flippers and the pattern on the turtle's head.

Use the HB pencil to add more subtle shading in the areas around the spots in the bottom flippers.

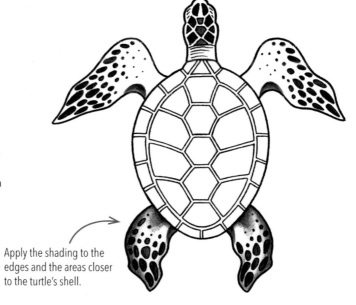

Apply the shading to the edges and the areas closer to the turtle's shell.

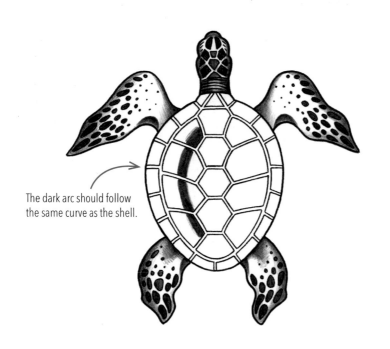

The dark arc should follow the same curve as the shell.

9 Use the HB pencil to shade the top flippers and then shade the head and neck. Use the 2B pencil to shade a dark arc on the left side of the shell.

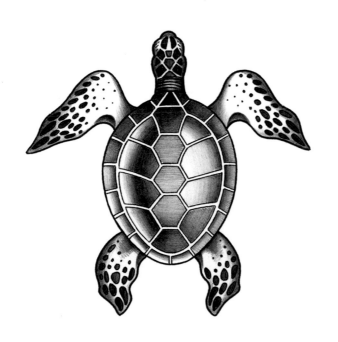

10 Use the 2B pencil to darken the top side of the shell and then continue to apply mid tone shading throughout the shell, making sure to blend the darkest tones into the mid tones and leave some lighter areas for contrast and to add a 3D appearance.

LEVEL ●●○○ NUMBER OF STEPS 10

Scorpions are part of the Arachnida class and are related to spiders, mites, and ticks. They're carnivorous and use their pincers to catch prey and their stingers to inject the prey with venom. Scorpions are typically thought of as strong, powerful, and dangerous. They're fierce hunters and can defend themselves against any creature that may try to attack them.

WHAT YOU NEED:
- Drawing paper
- HB pencil
- 2B pencil
- Eraser
- Black fineline pen

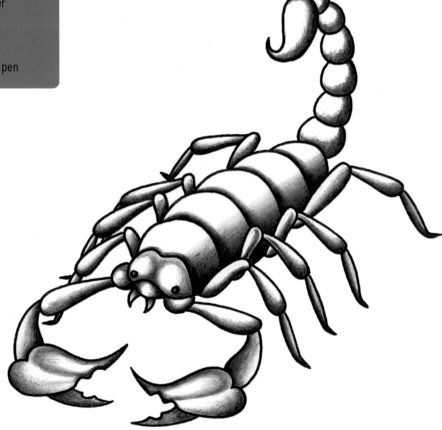

1 Using an HB pencil, lightly sketch an oval shape that leans toward the top right.

The widest point of each curved section should touch the line that runs through the length of the oval.

2 Draw a curved line that runs end to end through the length of the oval, following the same path as the outside edge of the oval.

Split the oval into six sections by drawing curves on the inside of the oval shape.

3 From the top end of the oval shape, draw a curve that points upward and then sharply bends back down toward the oval. Draw a second curve that follows the same path, but slightly tapers. (Think of a palm tree trunk.)

Split the form into sections by drawing four or five upside-down arcs that curve slightly and are evenly spaced.

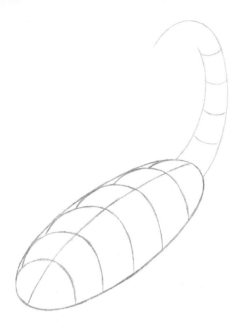

4 Draw slight curves along the outside edge of the tail. Each curve should start and finish from the arcs that run up the inside of the tail.

Draw a hook for the stinger at the end of the tail.

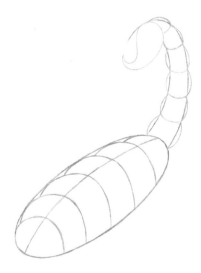

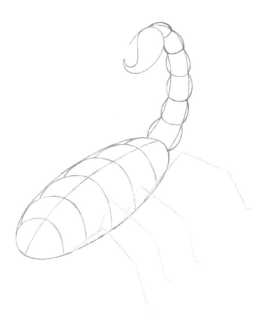

5 Begin drawing the legs by drawing four diagonal lines that start from the center of each section and point toward the top right. Next, draw slightly longer diagonal lines that point toward the bottom right, followed by matching lines that point slightly farther down and are approximately the same length as the first part of the legs. Draw four short lines at the very ends that point more to the right.

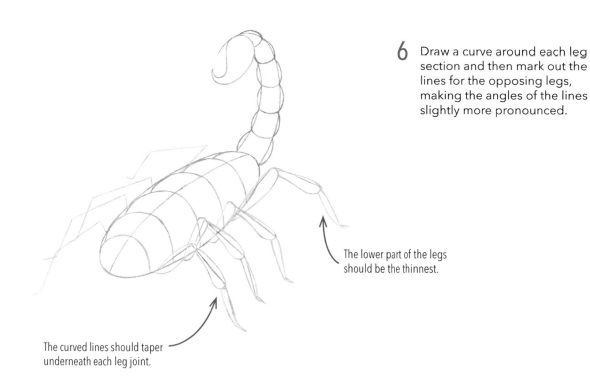

6 Draw a curve around each leg section and then mark out the lines for the opposing legs, making the angles of the lines slightly more pronounced.

The lower part of the legs should be the thinnest.

The curved lines should taper underneath each leg joint.

7 Fatten the opposing legs by drawing curves around each leg section. Give your scorpion a face and then mark out angled guidelines for the arms.

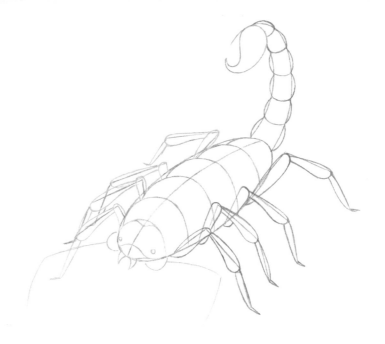

8 Draw a curve around each arm section like you did for the legs, but make the arms thicker. Draw in the pincers by first drawing teardrop shapes and then defining them. Add angled shapes that extend from the ends of the teardrop shapes to complete the pincers.

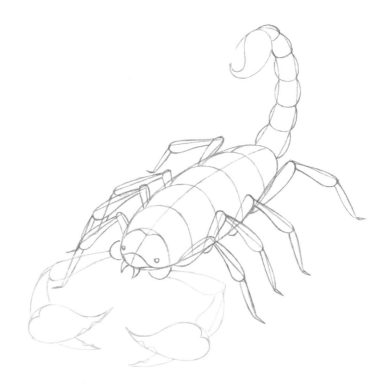

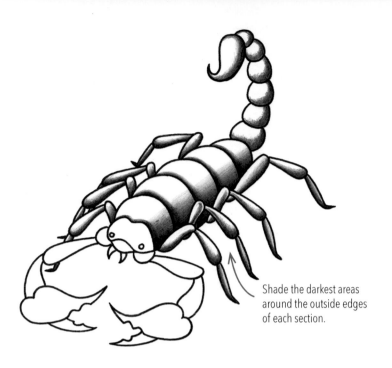

9 Using the black fineline pen, trace over the image and then erase any guidelines.

Shade the legs, tail, stinger, and body with an HB pencil. Use a 2B pencil to shade the darker areas, adding the darkest tone where the sections of the body, tail, and legs meet. Leave the top areas free of shading for a 3D effect.

Shade the darkest areas around the outside edges of each section.

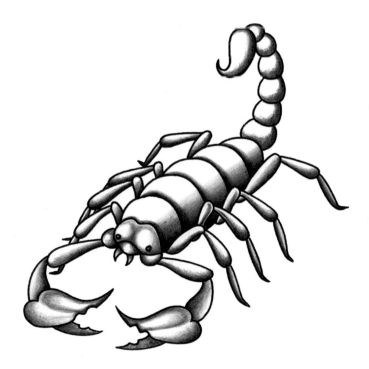

10 Shade in the face and the pincers.

SEAHORSE

LEVEL ●●○○ NUMBER OF STEPS 10

The seahorse is a fascinating creature, and it's easy to see where it gets its name. Seahorses can range in size from an inch to a foot. And although it may not look like it, this aquatic marvel has enough fish characteristics to be officially classified as a fish. Besides being beautiful to look at, seahorses are fun to draw.

WHAT YOU NEED:
- Drawing paper
- HB pencil
- Eraser
- Black fineline pen

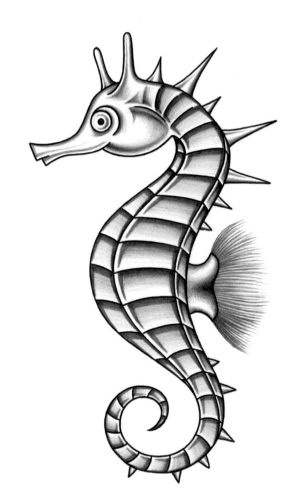

1 Using an HB pencil, lightly sketch a curve that looks like the number "6" turned on its side and then draw a rectangular shape to the left that points slightly downward.

2 Draw the body by drawing two wavy lines. These lines should curve to the left and then bend and taper toward the bottom right. The left line should curve farther out than the right.

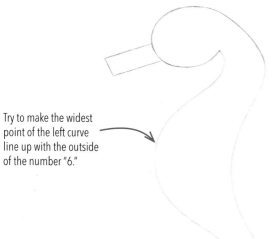

Try to make the widest point of the left curve line up with the outside of the number "6."

3 Draw a circular spiral at the bottom for the tail. Draw two curves on the inside of the body that follow the same paths as the outside edges.

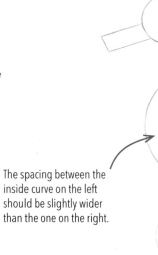

The spacing between the inside curve on the left should be slightly wider than the one on the right.

4 Outline the mouth and nose and then draw a large eye and two spikes on the top of the head.

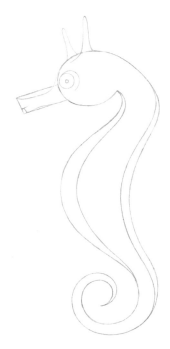

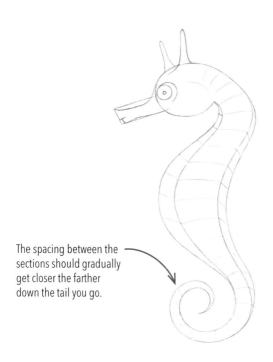

5 Divide the neck, body, and tail into multiple sections by drawing lines that flow with the body.

The spacing between the sections should gradually get closer the farther down the tail you go.

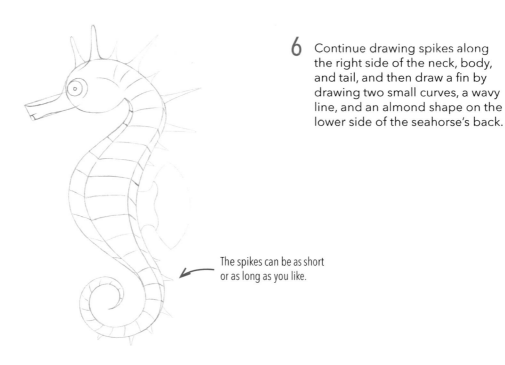

6 Continue drawing spikes along the right side of the neck, body, and tail, and then draw a fin by drawing two small curves, a wavy line, and an almond shape on the lower side of the seahorse's back.

The spikes can be as short or as long as you like.

7 Using the black fineline pen, outline the seahorse, but leave the fin's almond shape in pencil.

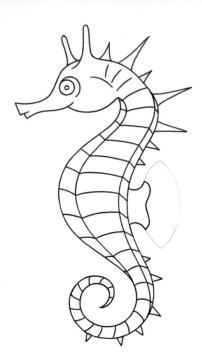

8 Use the HB pencil to shade inside the body sections. Shade inside the tops and sides of the sections, but leave some white space around the left edges on the inside, in the central areas, and around the bottom edges.

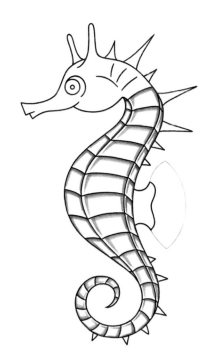

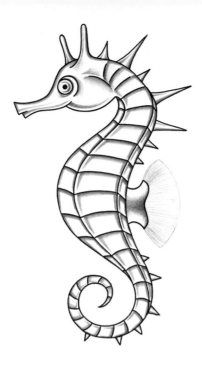

9 Fill in the pupil in the eye and add
 some shading to the face and the
 spikes. Lightly draw curved lines
 inside the fin that follow the same
 path as the almond shape.

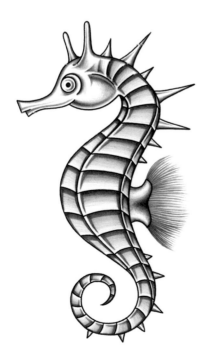

10 Use an eraser to soften the right
 edge of the fin and then use the
 HB pencil to draw light, whispy
 lines to complete the fin.

 Continue to add shading until you
 are satisfied with the result.

LEVEL ●●●○ NUMBER OF STEPS 10

This project is a fun take on a monkey astronaut. Primates were once sent into space so scientists could better understand the effects space would have on human beings. A monkey named Albert II became the first monkey sent into space on June 4, 1949, and in total there were 32 primates sent into space.

WHAT YOU NEED:

- Drawing paper
- HB pencil
- Eraser
- Black fineline pen

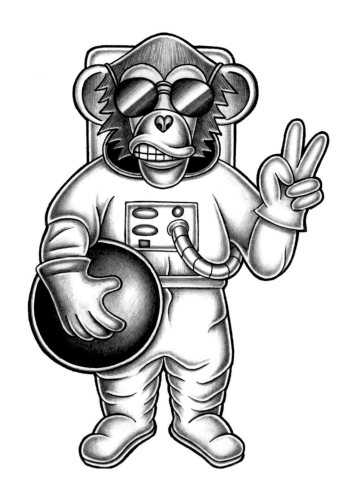

1 Using an HB pencil, draw a
vertical line and then draw two
short curves at the top that
extend from the vertical line out
to each side and slightly flick
up at the ends.

Draw curves on each side that
flow downward toward the
vertical line but then round off
at the bottom to form the chin.
(The distance between the
top curve and the bottom
curve should be approximately
one third of the length of the
vertical line.)

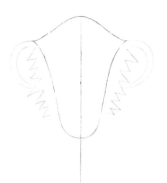

2 Add jagged edges on each side
that represent fur for the sides of
the monkey's face. Draw two arcs
on each side for the ears and then
draw similar arcs inside of the
originals.

3 Draw an arc that runs through the center of the face and then draw two oval shapes above the arc for the sunglasses. Connect the lenses by drawing two sets of small curves for the bridge and then draw the temples from the outsides of the lenses up to the ears.

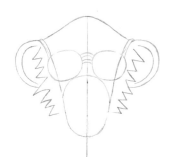

4 Draw two arcs above the sunglasses for the hairline and then draw a small heart shape for the nose and two short curves to represent the nostrils. Draw the mouth and teeth.

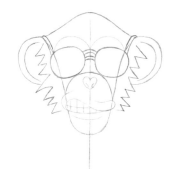

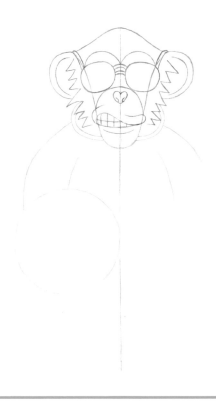

5 Add the collar by drawing two curves from each side of the face that swing around from the bottom of the ears to the lower sides of the chin. Draw matching curves inside the originals.

Mark out the shoulders by drawing curves from the collar that bend down toward the lower left and lower right. Mark out the upper arms by drawing two smaller curves that follow the same paths as the shoulder lines.

Draw a circle on the lower left side of the vertical line for the helmet.

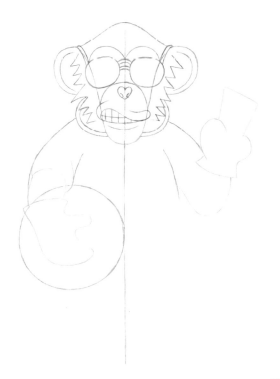

6 Define the arm on the left by drawing a curved line for the top of the glove and then drawing a line that swings down onto the helmet and to the right for the outside of the glove. Continue to outline the right side of the glove and then mark out an area for the thumb.

Draw guidelines for the arm and glove on the right side.

7 Draw in the fingers on each hand. Draw a module box on the chest and then draw a hose that starts from the right side of the module and wraps around to the back of the monkey's body. Draw a belt just below the hose.

Draw another circle inside the original circle for the helmet.

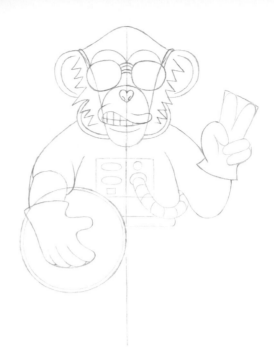

8 Draw guidelines for the legs, feet, and backpack.

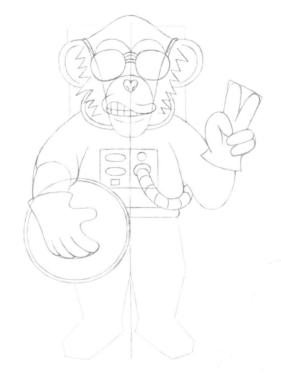

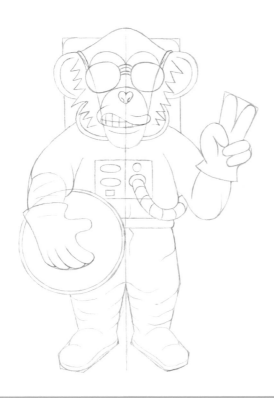

9 Define the legs by adding some creases and folds. Draw some curves around the sides and tops of the feet for the shoes.

Add some creases in the arms. Round off the top corners of the backpack.

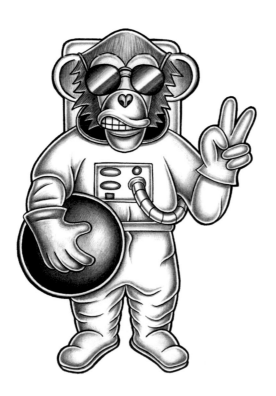

10 Trace over the drawing with a black fineline pen and then erase any guidelines.

Apply shading with the HB pencil and, if desired, add a bold outline to make it pop more, leaving some white space at the edges to add a 3D effect. Shade the areas inside the collar and helmet darker, leaving some white space near the center of the helmet.

Shade the sunglasses using gradually darkening lines to create a mirrored effect.

LEVEL ● ● ● ○ NUMBER OF STEPS 10

The praying mantis is named for its unusual stance, which mimics someone praying. From an artistic viewpoint, the creature has many features that are fun to capture. From its unique body shape to its triangular-shaped head and menacing forelegs, it makes an intriguing subject.

WHAT YOU NEED:

- Drawing paper
- HB pencil
- Eraser
- Black fineline pen

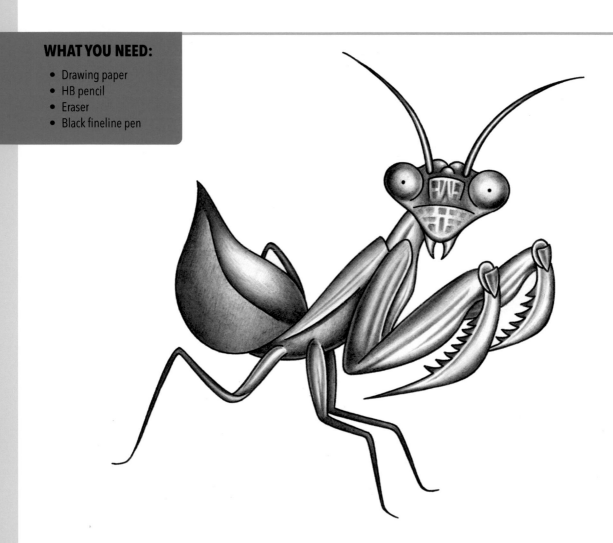

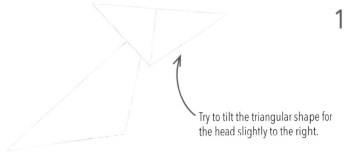

1 Using an HB pencil, lightly sketch an upside-down triangular shape and then draw a line through the center. (This feature will serve as a guide for the head.)

From the bottom left side, draw a larger triangular shape that will serve as a guide for the body.

Try to tilt the triangular shape for the head slightly to the right.

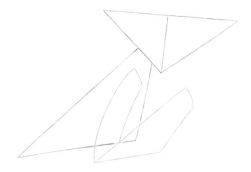

2 Now you need to draw a guide for one of the arms. Draw an elongated curved shape on the right side of the guide for the body, extending it just past the bottom of the guide and then draw a second, shorter line that is parallel to the first line. Draw a cone-like shape with a slightly rounded end that extends from the first line and points up toward the top right.

3 Draw a hook-like shape from the end of the arm that gradually gets thicker toward the bottom before tapering off into a sharp point.

Draw in the second arm that extends from the end of the front arm, but because most of it will be hidden, only draw the end of the arm and the hook.

4 Inside the top right triangular shape, draw one side of the head and face, and add an antennae.

5 Complete the head and face by drawing the opposite side and then draw two small spikes that look like fangs for the mouth.

Define the right side of the body and left arm by giving them some shape and then draw a small arc and shield-like shape inside the top of the hook.

6 Define the other arm and smooth off the right side of the hook by drawing a curve. Add the shield-like shape to the other arm and then draw some spikes along the left sides of both hooks. Define the neck and the left side of the body.

7 Draw a large leaf shape extending from the bottom left side of the body.

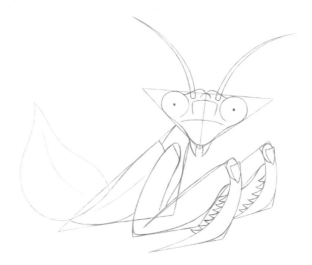

8 Draw two legs beneath the front of the body that point to the right and then draw two legs that point to the left, but only draw the top half of the far leg because the rest of it is hidden behind the body.

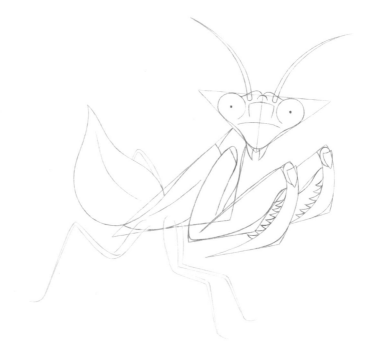

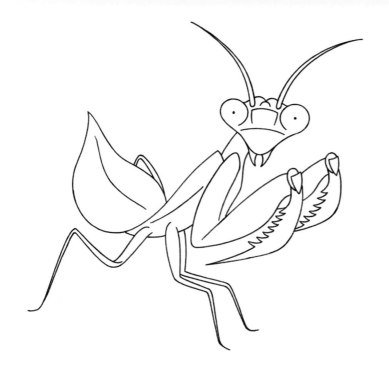

9 Using a black fineline pen, trace over the image and then erase any guidelines.

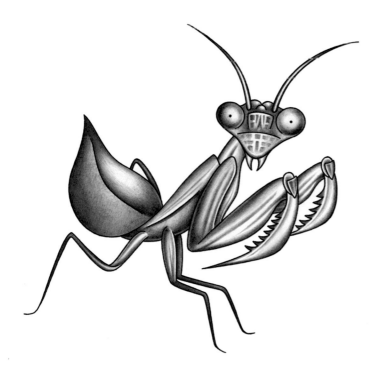

10 Using the HB pencil, shade in the mantis. Or if you prefer, give him some color.

LEVEL ●●●● NUMBER OF STEPS 10

This is a skeleton riding a shark—it's an extreme image, but what does it mean? I like to imagine it's a cowboy who tried surfing but realized he was better at busting broncos. This fellow might have wiped out permanently, but he's having fun in his new form!

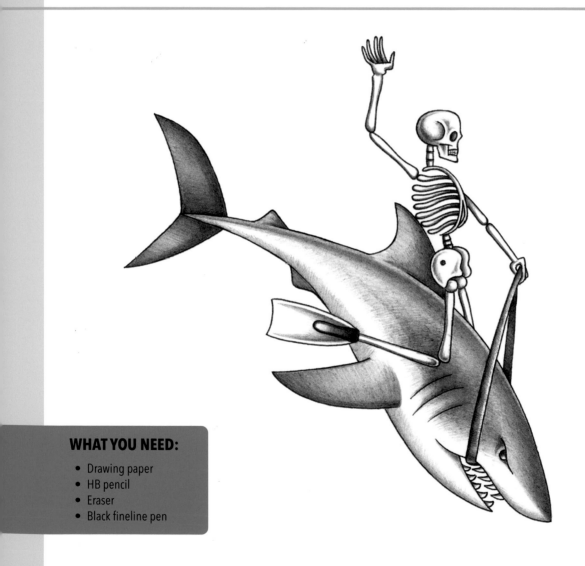

WHAT YOU NEED:
- Drawing paper
- HB pencil
- Eraser
- Black fineline pen

Make the left third of the shape narrower, and taper it at the end. (This will be the shark's tail.)

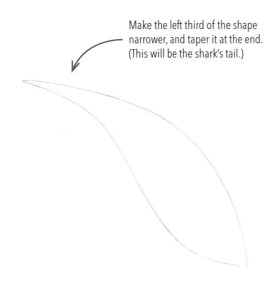

1 Using an HB pencil, lightly sketch a slender, leaf-like shape that falls down toward the right side.

2 Draw a fin approximately halfway down the underside of the widest point of the leaf-like shape and then draw two cone-like shapes for the tail fin.

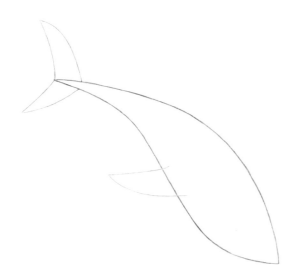

3 Draw a wide hook-like shape for the top fin and then add two small pyramid-shaped fins on each side of the narrow part of the tail. Add a couple of curved lines for the jaws.

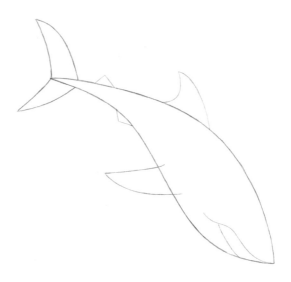

4 Draw a few slightly curved lines for the gills and then draw in the eye and some teeth.

Begin drawing the skeleton by marking out three rounded shapes along the right side of the top fin. The top shape should be small and oval, the bottom shape should be almost circular, and the middle one should be an egg shape and the largest of the three.

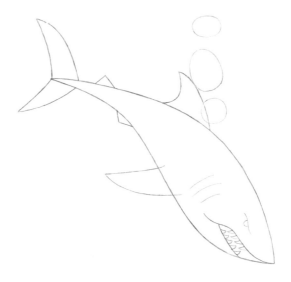

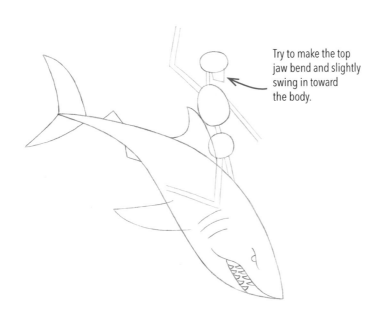

Try to make the top jaw bend and slightly swing in toward the body.

5 Draw the bottom part of the skull by drawing three slight diagonal lines below the top oval.

Connect the rounded shapes by drawing short, parallel lines for the neck and spine. Draw longer parallel lines for the arms and legs.

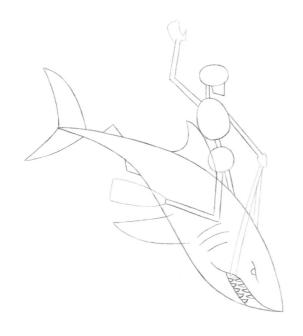

6 Draw a small cone-like shape with a hook for the left hand and then draw a curved, pointed shape for the hand that will hold the reins.

Draw slightly curved lines for the reins and then add a flat-ended cone shape for the flipper.

7 Define the skull, hands, and skeleton's body by drawing the bone details inside the guidelines.

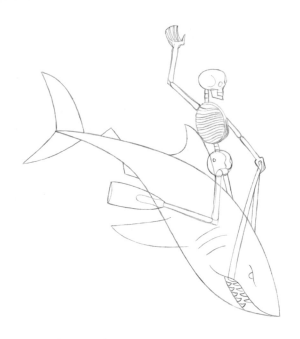

8 Use a black fineline pen to trace the drawing and then erase any guidelines.

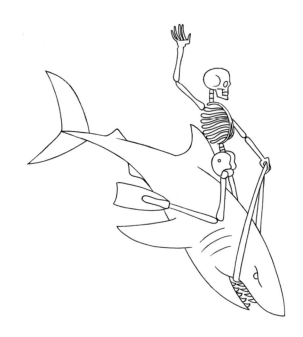

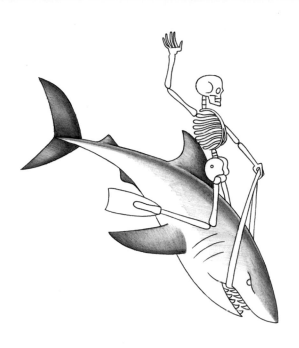

9 Use the HB pencil to add shading to the top of the shark and around the fins. Darken the outer edges of the fins to add a 3D effect.

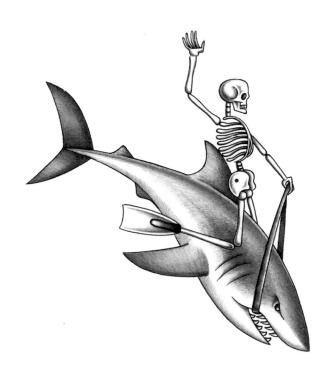

10 Add the pupil to the shark's eye and then shade to darken the eye. Apply final shading to the skeleton, reins, and flipper.

OTHER FUN STUFF

This chapter contains a mixed bag of different subjects that I think are very cool but don't really fit anywhere else. And that's okay! I think these drawing projects stand perfectly well on their own. There is a wide range of visually appealing things for you to learn how to draw in this chapter. You will use all of the drawing techniques you've learned up to this point and maybe use a few new ones, too.

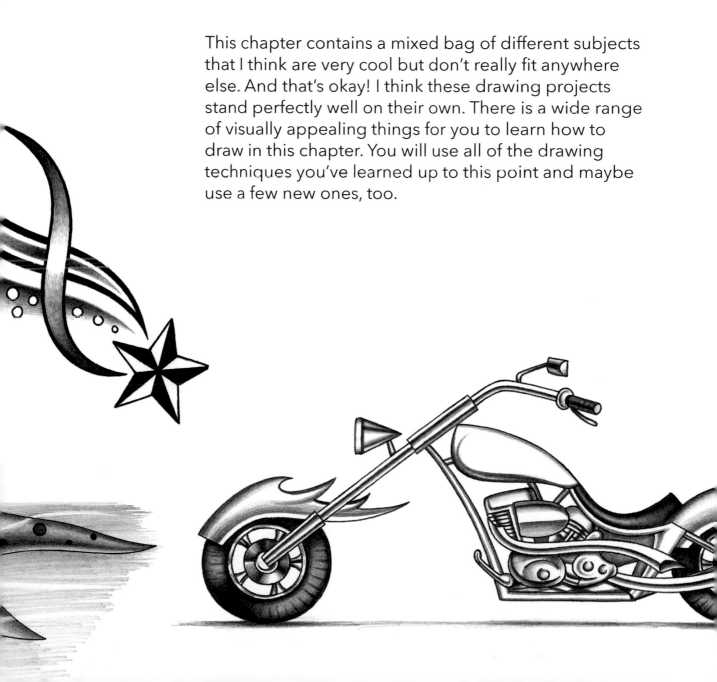

LEVEL ● ○ ○ ○ NUMBER OF STEPS 10

Despite its name, a shooting star is not an actual star but a meteoroid that falls into Earth's atmosphere and burns up prior to impact. Shooting stars are considered lucky, probably because they are not seen very often and do not last very long when they are visible. This is likely why many people believe they should make a wish whenever they do see one.

WHAT YOU NEED:

- Drawing paper
- HB pencil
- Black fineline pen
- Black marker pen

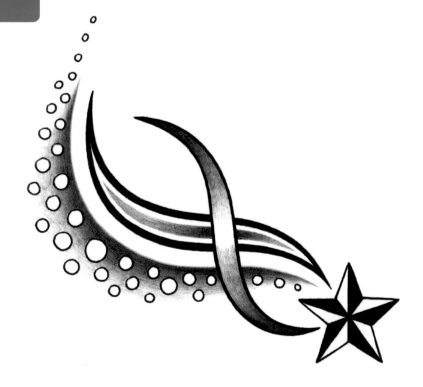

1 Using an HB pencil, lightly sketch a small square and then divide it into four squares by drawing vertical and horizontal lines through the center of the square.

2 From the top point of the vertical line, draw a diagonal line on each side that extends to the bottom lines of the bottom squares. These lines should fall about one third of the distance from the outside corners of each bottom square.

Next, draw a horizontal line about one third of the way up from the center horizontal line. Connect the ends of this line with two more diagonal lines that begin at the ends of the new horizontal line and extend down to meet the ends of the diagonal lines that touch the bottom squares. The result should be a star shape.

3 Erase the guidelines and then draw lines from each of the five points to the center point of the star.

4 Draw a wavy line from the left side of the star that swings up and then bends back toward the top left. Draw a second wavy line next to the first line that starts at the same bottom point but becomes wider at the middle and then tapers back to meet the first line at the top point.

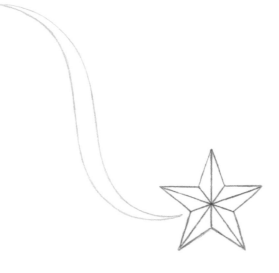

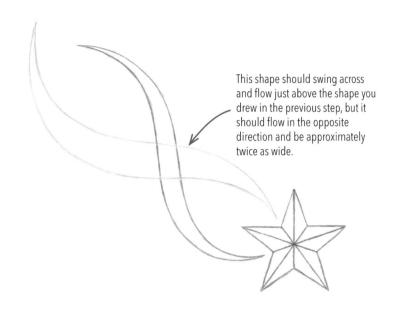

This shape should swing across and flow just above the shape you drew in the previous step, but it should flow in the opposite direction and be approximately twice as wide.

5 Repeat the same process, but this time draw two wavy lines from the top left of the star that swing out and intersect the first two lines.

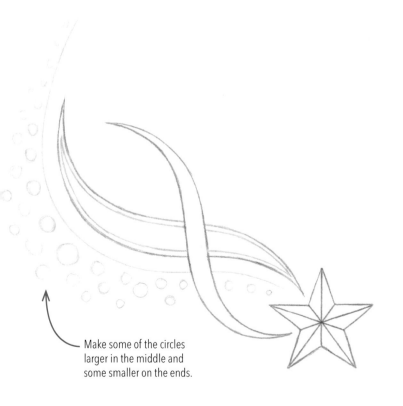

Make some of the circles larger in the middle and some smaller on the ends.

6 Erase the overlapping lines so the shape you just drew underlaps the original wavy shape and then double up the bottom shape by drawing a narrow line along the inside edges. Draw another wavy line below the bottom shape that follows the same path but extends beyond the bottom shape and bends toward the upper right.

Next, draw several different-sized circles below this line that follow the same path as the new line.

7 Use a black fineline pen to trace the image, but leave the line above the circles in pencil.

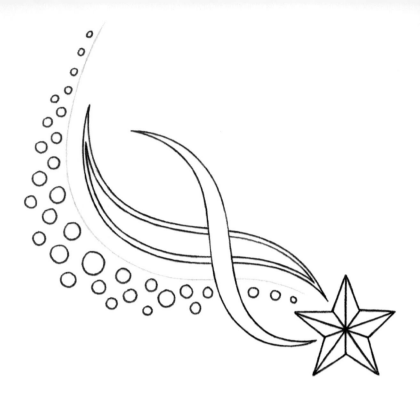

8 With a black marker pen, fill in five sides of the star to create a 3D effect and then black out the wavy double-lined shape on the left.

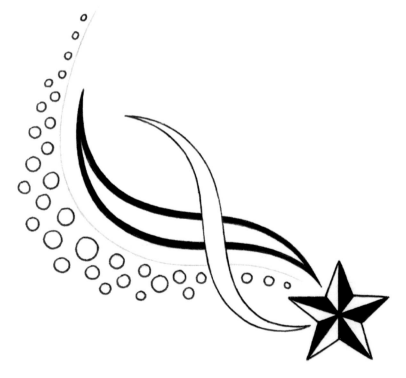

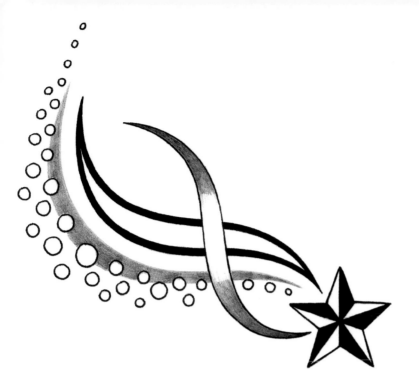

9 Using the HB pencil, shade both ends of the overlapping wavy shape and then shade along the line above the circles.

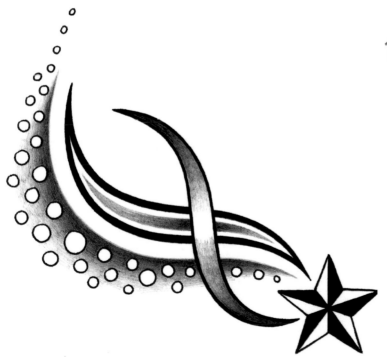

10 Apply a lighter tone of shading to the lower areas behind the circles and then add more darker shading to the area closest to the line above the circles.

Apply some light shading inside the overlapping wavy shape, leaving the center area the lightest and the ends the darkest.

Create a shaded shape inside the underlapping wavy shape that follows the same path as the larger shape. Shade the area that falls under the overlapping shape the darkest and leave the ends the lightest.

LEVEL ●○○○ NUMBER OF STEPS 8

This is a fun subject to learn to draw and share with others. There is something magical about capturing an image inside a bubble; the landscape captured in this project might make someone think of a distant place in a faraway land.

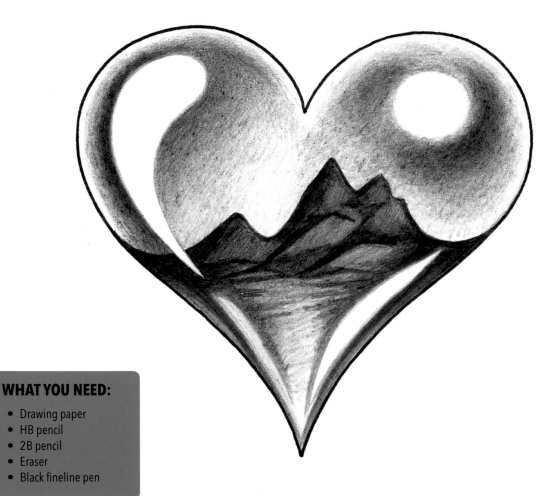

WHAT YOU NEED:
- Drawing paper
- HB pencil
- 2B pencil
- Eraser
- Black fineline pen

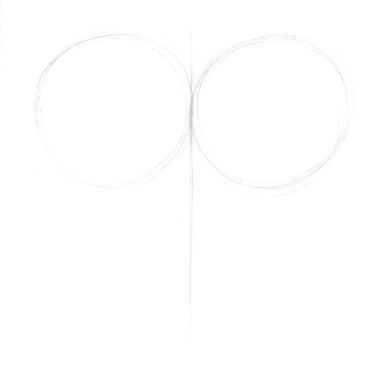

1 Using an HB pencil, lightly sketch two side-by-side circles and then draw a vertical line between them.

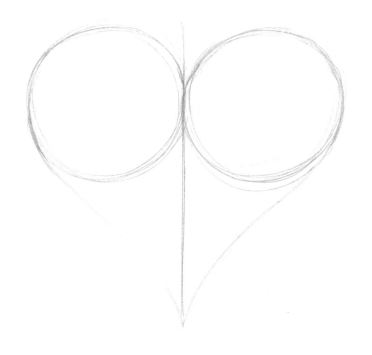

2 Draw two lines from the lower outside edges of the circles that bend slightly inward and then begin to curve back out just before meeting at the bottom point of the vertical line.

3 Using a black fineline pen, trace around the heart and then erase all pencil marks.

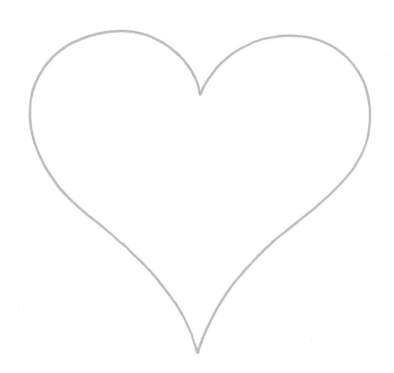

4 Using the HB pencil, draw a jagged mountain range along the center of the heart, making the ends of the mountains curve into the outside edges of the heart.

Next, draw a small circle at the top right of the heart and then draw a shape at the top left of the heart that follows the outside edge of the heart and is rounded at the top and tapers to a point at the bottom.

Draw a thinner shape at the bottom right of the heart that again follows the path of the outside edge of the heart but tapers at both ends.

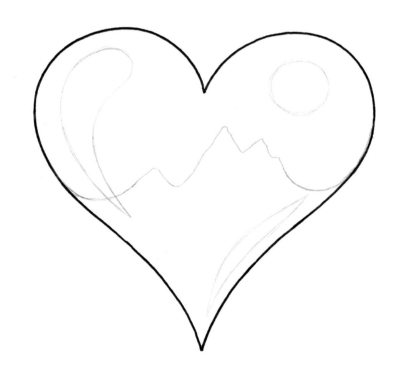

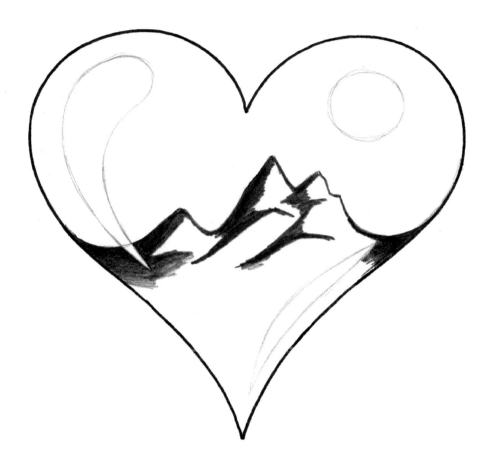

5 Using a 2B pencil, shade the left sides of the mountains and the right side edge beneath the right side curve of the range. Draw and shade a couple of smaller peaks for definition.

6 Using the HB pencil, shade the right sides of the mountains and then shade beneath the mountains. Darken the lower outside edges of the heart on both sides. Add some additional shading around the shapes at the top of the heart, leaving some lighter areas along the edges of the heart to create a 3D effect.

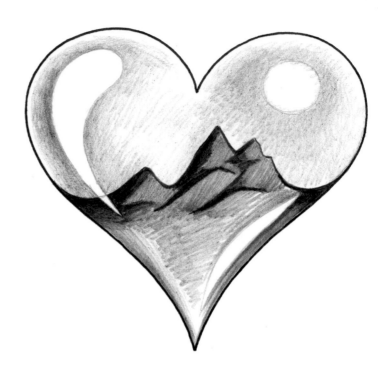

7 Continue adding shading to the darkest areas.

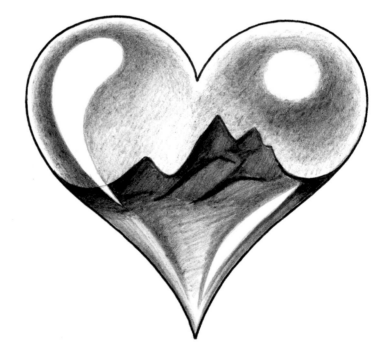

8 Using the 2B pencil, continue adding shading to the darkest areas until you are satisfied with the result.

LIPS

LEVEL ● ○ ○ ○ NUMBER OF STEPS 10

Lips have more than a million different nerve endings, making them a very sensitive part of our bodies. They are also very delicate; they only have 3 to 6 layers of cells, compared to the 16 layers our skin has. Lips can convey a lot through a smile, a frown, a grimace, or nervousness, making them a very worthwhile thing for any artist to know how to draw.

WHAT YOU NEED:

- Drawing paper
- HB pencil
- Eraser
- Tissue paper

1 Using an HB pencil, lightly sketch a rectangle. The length of the rectangle should be approximately twice the height.

Split the rectangle into four smaller rectangles by drawing a vertical line and then a horizontal line through the center of the original rectangle.

2 Draw two diagonal lines inside the two top rectangles that start from the outside bottom corners and stop slightly past the centers of the top edges.

Draw two more diagonal lines in the two bottom rectangles that start from the top outside corners and stop close to the centers of the bottom edges.

3 Draw a short, slight, upside-down arc at the top that sits in the center of the larger rectangle.

Next, draw a longer, more slight arc at the bottom that curves up to the diagonal lines.

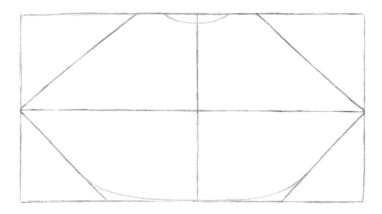

4 Round off the top points of the upper lip and then round off the corners of the lips. Draw a slight curve on the inside of each diagonal line.

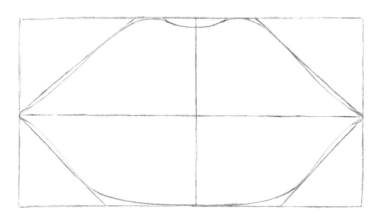

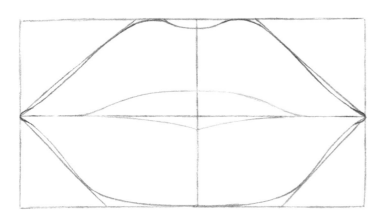

5 Draw an arc inside the top two rectangles that starts at the center line in the top left rectangle and arcs up and across before bending back down to the center line in the top right rectangle.

Next, draw two very slight curves underneath the horizontal line and inside the bottom two rectangles that meet at the center vertical line.

6 Draw slight curves to round off the corners of the top lip and then mark out lines for the teeth.

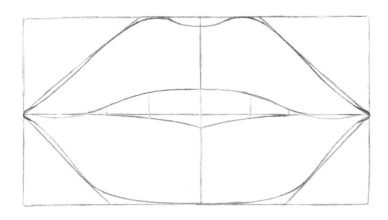

7 Erase any guidelines. Using the HB pencil, shade both lips in a consistent tone and then apply slightly darker shading to the top lip and to the lower edge of the bottom lip.

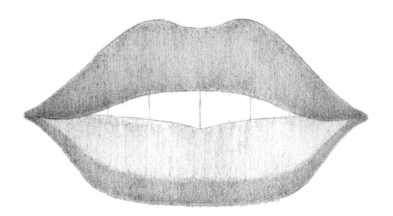

8 Using the tissue paper, gently smudge the shaded areas until they look smooth.

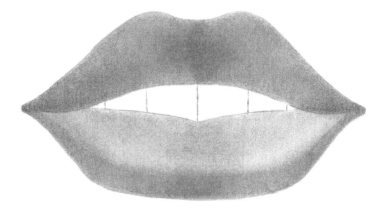

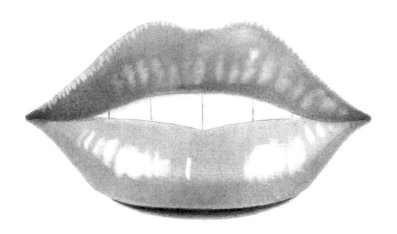

9 Using the pointed tip of an eraser, take off some of the pencil to create highlights.

Next, add a darker area below the bottom lip to create a shadow. Add additional shading to the corners of the mouth.

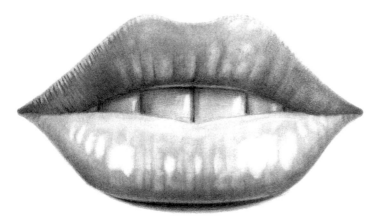

10 Shade the teeth, adding darker areas at the top of the teeth and using the eraser to add highlights to the right sides of the teeth. Continue shading and highlighting until you are satisfied with the result.

LEVEL ● ● ○ ○ NUMBER OF STEPS 10

A peacock, or Indian peafowl, is a beautiful and graceful creature, and part of what makes it so striking is its feathers. The bright and lovely plumage we most often associate with peacocks is actually only found on the male of the species. Artists have long loved the peacock, and its feathers, as symbols of beauty, wealth, rebirth, decadence, and pride.

WHAT YOU NEED:

- Drawing paper
- HB pencil
- Black fineline pen
- Coloring pens

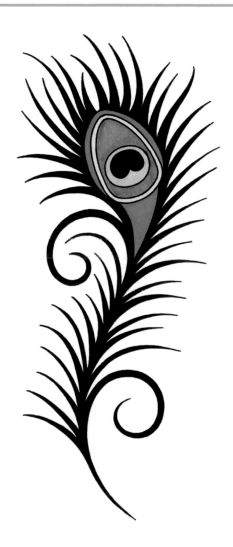

1 Using an HB pencil, lightly sketch a long vertical wavy line.

2 From the top end of the wavy line, draw two arcs that join at the top and then swing about one fifth of the way down the wavy line to create an egg-like shape. Draw curves on each side and below the egg shape.

Try to make the egg shape flow in the same direction as the wavy line.

3 Draw two more egg-like shapes inside the large egg shape.

4 Draw an oval in the center of the shape and then add an upside-down heart shape that is flat on the top end. Erase the portion of the wavy line that is inside the egg and curve shape.

5 Draw a tapered swirl on the upper left side of the wavy line and then draw a second tapered swirl closer to the bottom and on the right side of the wavy line.

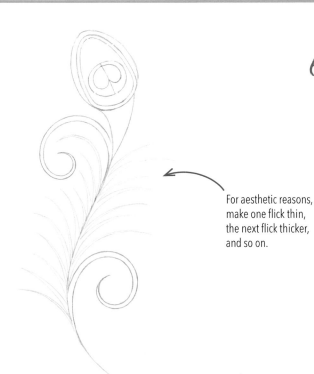

6 From just above the right swirl, begin drawing some flicks that all flow in the same direction on the wavy line and extend as far out as the swirl. Repeat the same process on the opposite side.

For aesthetic reasons, make one flick thin, the next flick thicker, and so on.

7 Draw some flicks on the left side of the large oval. Begin by drawing a few that follow a similar path to the swirl below, but then add some flicks that point upward as you progress toward the top of the form.

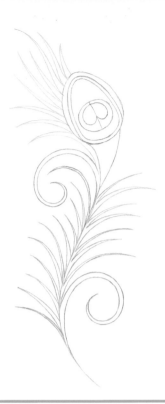

8 Repeat the same process for the top right side of the feather, adding flicks that follow the same path as the bottom swirl but then adding some at the top that point upward.

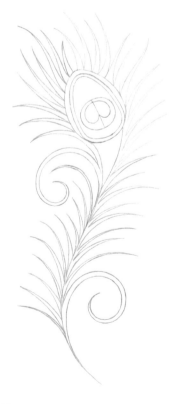

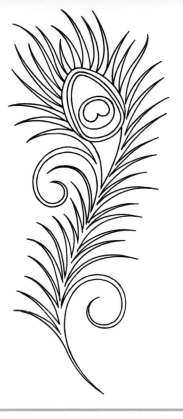

9 Using a black fineline pen, trace over the image.

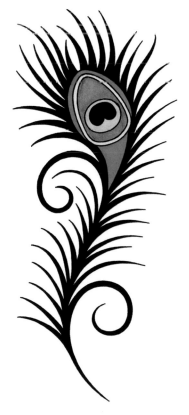

10 Color the center areas with coloring pens and then fill in the rest of the feather with a black coloring pen.

HOW TO DRAW AN EYE

LEVEL ●●○○ NUMBER OF STEPS 10

"The eye is the window to the soul" is a well-known proverb, and there is a lot of truth to that. Most of our emotions can be seen and communicated through our eyes. And because the eye is such an important part of the face, it's essential to know how to draw it well. It can be a fun thing to draw on its own or when it's combined with other subjects.

WHAT YOU NEED:
- Drawing paper
- HB pencil
- Eraser
- Straightedge
- Black fineline pen

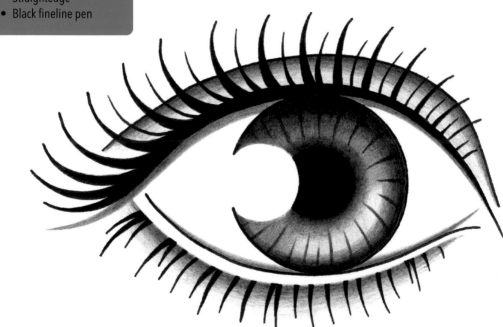

The length of the rectangle should be about twice the height.

1 Lightly sketch a rectangle.

Next, draw two curves inside the rectangle, starting the first curve from the lower right side of the rectangle and curving it up to the top edge and then back down to the center of the left side. Start the second curve from the same point on the left side, but curve it down to touch the bottom edge of the rectangle and then back up, stopping before it reaches the right side of the rectangle.

The top eyelid should take a sharp turn and taper toward the corner of the eye.

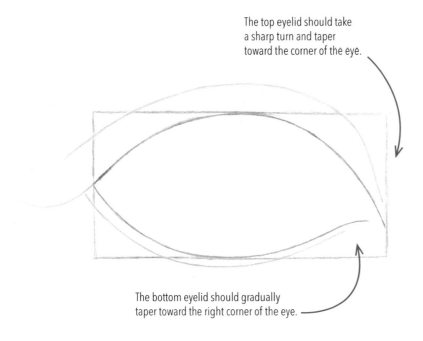

The bottom eyelid should gradually taper toward the right corner of the eye.

2 Now it's time to add the eyelids. Draw a curved line above the top of the rectangle and another below the rectangle that both follow the same path as the outside edges of the eye.

Extend the top left side of the eye by drawing a curve that sweeps down and then up slightly.

3 Draw a large circle in the center of the eye that touches the top and bottom sides of the rectangle.

Next, using a straightedge, draw two lines of equal length that cross in the center of the large circle. (This will help you draw a consistent curve and keep the iris in the center.) Mark out a square to help you draw a consistent curve for the pupil and then draw a smaller circle in the center of the square for the pupil.

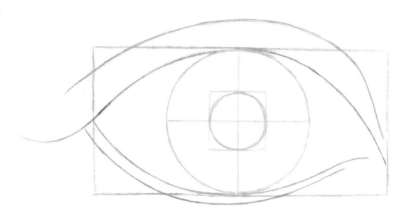

4 Draw a slightly larger circle that overlaps the left side of the pupil but doesn't quite overlap the left side of the iris. Draw some eyelashes around the top of the eyelid, starting from the left side and working around to the right.

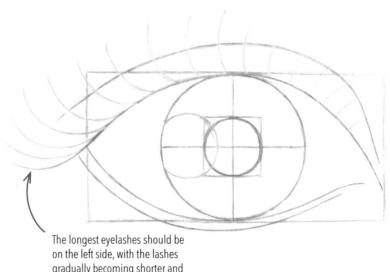

The longest eyelashes should be on the left side, with the lashes gradually becoming shorter and less curved as you work your way to the right.

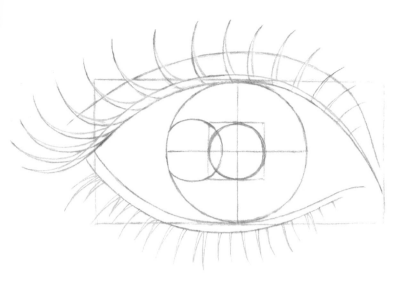

5 Double up the top eyelashes by drawing another line next to each lash to create tapered spikes. Double up the top curved line of the eye so it's thicker.

Draw some smaller eyelashes for the bottom of the eye, grouping a few together to create a more natural appearance.

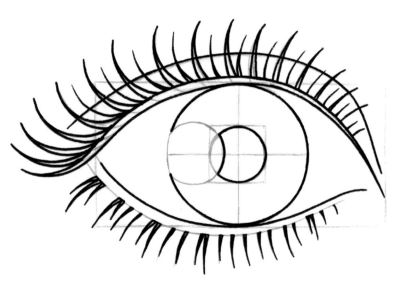

6 Using a black fineline pen, trace over the image, but leave both the circular shape next to the pupil and the bottom edge of the lower eyelid in pencil.

7 Fill in the eyelashes and pupil with the black pen and then erase all guidelines, making sure to leave the circular shape next to the pupil and the bottom edge of the lower eyelid in pencil.

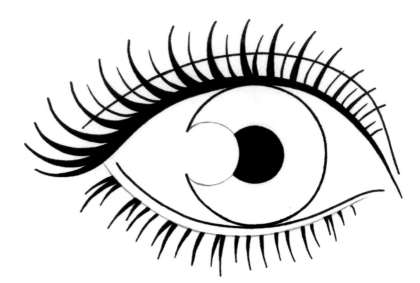

8 Use the HB pencil to lightly shade the iris and eyelids. Darken the top eyelid and top and right sides of the iris. Lightly shade the area behind the lashes on the lower eyelid. (Try to keep the shading tone in this step even and consistent throughout.)

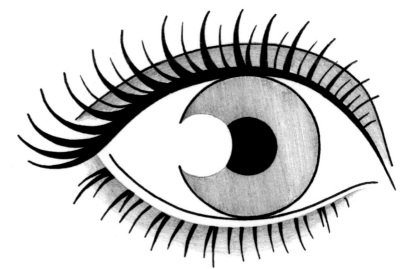

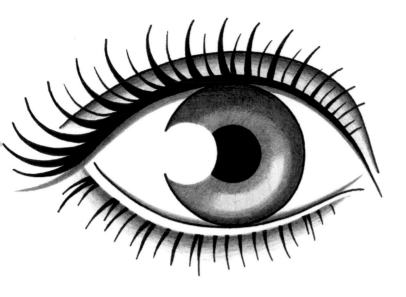

9 Add a shadow below the top lashes that extends out beyond the left corner of the eye. Add some darker shading at the very top edge of the upper eyelid.

Add a little shading along the bottom edge of the white of the eye.

Add some mid tone shading inside the iris, making the areas around the outside edges darkest while leaving a small curved area on the lower right corner of the iris the lightest to give the impression of light reflecting inside the eye.

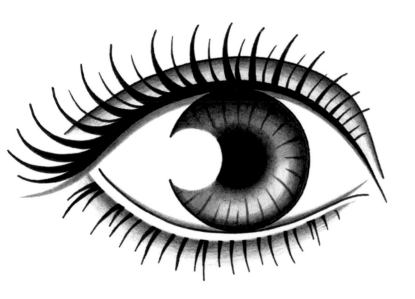

10 Add some final touches by further darkening the outside of the iris and then drawing some curved lines inside the iris for extra detail.

GUITAR & FLAMES

LEVEL ● ● ○ ○ NUMBER OF STEPS 10

Electric guitars are anything but laid back and are almost always associated with rocking out. They look modern but classic, and are fun to draw because of their curves and fluid lines. The stylized flames in this project add visual interest and makes this drawing that much cooler.

WHAT YOU NEED:

- Drawing paper
- HB pencil
- Eraser
- Straightedge
- Black fineline pen
- Coloring pencils

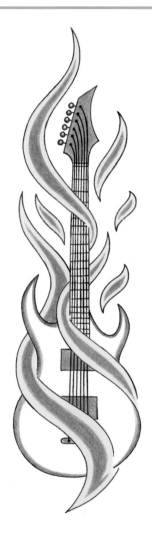

The lower horizontal line should be slightly wider than the upper line.

1 Using an HB pencil, lightly sketch a vertical line and then split the line into three sections by drawing two short horizontal lines. The spacing for the bottom two sections should be approximately the same, but the top section should be about half the length of one of the bottom sections.

2 Draw two vertical lines connecting both ends of the small horizontal lines. Draw two offset horizontal lines near the middle of the vertical line and then draw a wider horizontal line at the bottom of the vertical line. Draw two diagonal lines to connect the ends of the offset middle and bottom horizontal lines.

3 Draw two wavy lines on the inside of the guidelines that connect at the bottom to create the guitar body.

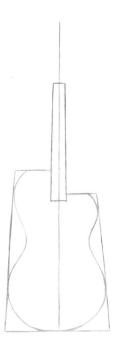

4 Draw two curved lines from the top ends of the wavy lines that sweep down and then back up to meet corners of the guitar neck.

Draw the headstock by drawing a diagonal line with a sharp point on the left and a curved line with two sharp points on the right.

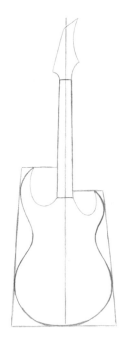

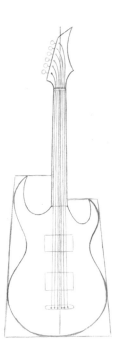

5 Sharpen your pencil for this next step! Draw six small circles with connecting lines on the headstock for the tuning pegs. Draw an elongated oval for the bridge on the lower part of the guitar's body.

Next, using your straightedge, draw two small rectangles on the body for the pickups and then draw six lines for the strings. The lines for the strings should run from the bridge up through the body and neck before bending slightly to the left at the top of the headstock.

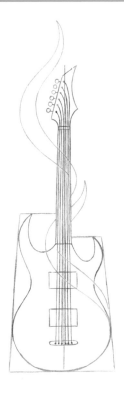

6 Draw wavy lines for flames that taper at the ends. Draw one from the lower right side of the guitar's body that flicks up, across, and around the back of the guitar neck. Draw a second flame that wraps around the neck and flicks off, up, and above the headstock.

7 Draw another large flame that starts just below the bottom of the guitar's body and then swings around and underneath the left side to flick off away from the left side of the neck. Draw three shorter flames on the right side and then draw one on the left that falls between the two large flames.

8 With a black fineline pen, outline the image. Erase all guidelines and any areas where the flames cross over the guitar.

For extra detail, use the straightedge to draw horizontal lines through the length of the guitar's neck for the frets.

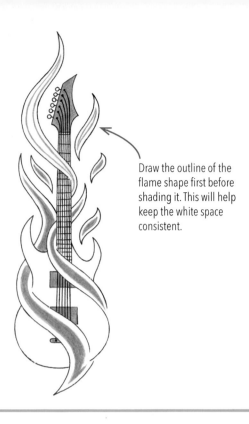

Draw the outline of the flame shape first before shading it. This will help keep the white space consistent.

9 Using an orange coloring pencil, shade inside the flames, but leave some white space around the outside edges. Using a blue coloring pencil, shade the headstock, pickups, and bridge.

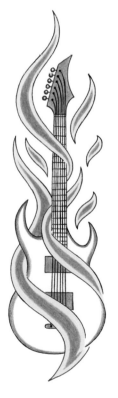

10 Color the outside of the flames with a yellow coloring pencil and then use an HB pencil to shade the tuning pegs and the outside edge of the guitar's body.

HOW TO DRAW THE **LOCH NESS MONSTER**

LEVEL ●●○○ NUMBER OF STEPS 10

The Loch Ness Monster (or Nessie), is a mythical creature in Scottish folklore that is believed to live in a large lake in the Scottish Highlands. Nessie has been described as a large, prehistoric aquatic reptilian creature with four flippers and a long, eel-like neck. This monster is mysterious, more than a little interesting, and a wonderful drawing subject.

WHAT YOU NEED:
- Drawing paper
- HB pencil
- Eraser
- Black fineline pen

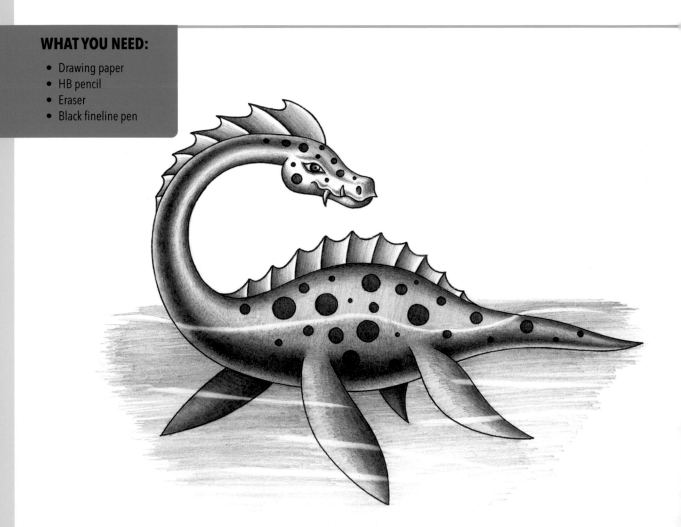

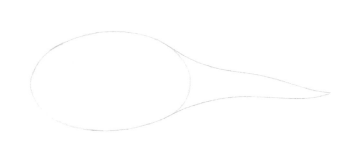

1 Using an HB pencil, lightly draw an oval. Next, from the right side of the oval, draw a cone-like shape with a slight wiggle at the end. The oval and cone-like shape should be approximately the same length.

Make the top curve extend a little farther out than the bottom one.

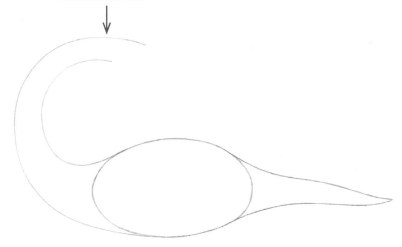

2 Draw two curves from the left side of the oval that swing out to the left before bending up and then back toward the right.

3 Draw two curves for the side of the head and then at the end draw an offset rectangle that looks like a diamond shape.

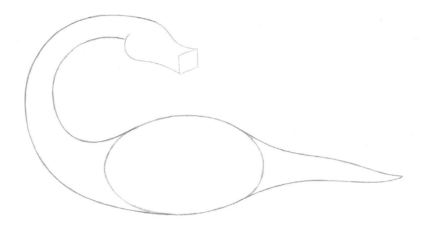

4 Draw two flippers. Draw one from the bottom left side of the oval that points toward the right and then draw another one that extends from the bottom left side of the neck and points toward the left.

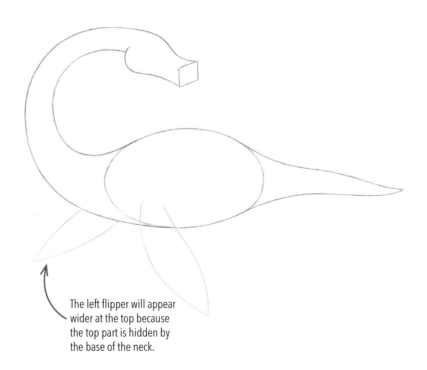

The left flipper will appear wider at the top because the top part is hidden by the base of the neck.

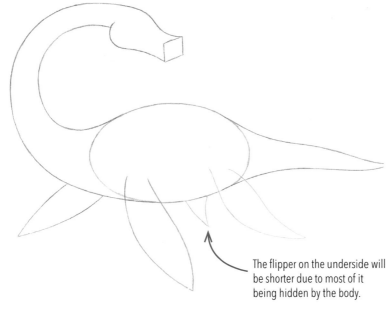

5 Draw two more flippers for the back side that curl slightly to the right.

The flipper on the underside will be shorter due to most of it being hidden by the body.

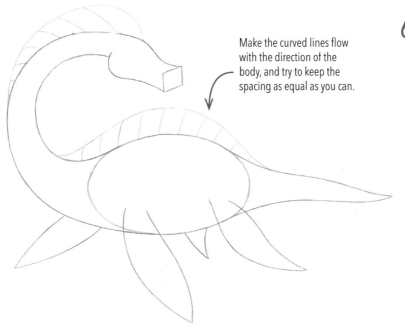

Make the curved lines flow with the direction of the body, and try to keep the spacing as equal as you can.

6 Draw a crest along the top side of the head and neck and then draw another crest along the top side of the body. Split the crests into multiple sections by drawing curved lines on the inside of each crest.

7 Define the face by giving your monster a mouth, teeth, and an eye and then draw some spots on the face and body.

Next, draw small curves inside each top section of the crests.

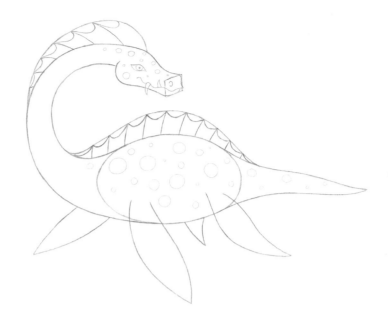

8 Using the black fineline pen, trace over the drawing and then erase all guidelines.

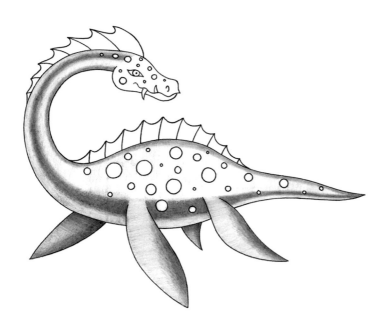

9 Using the HB pencil, begin to apply some shading. Shade darker tones for the underside of the belly, neck, and the two flippers that sit behind the body.

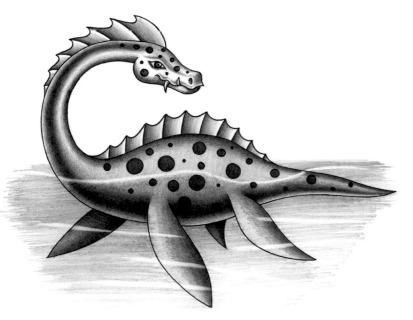

10 Shade in the crests, fill in the pupil of the eye, and fill in the spots on the head and body. Lightly shade some water and then use the edge of the eraser to add highlights. Continue shading until you're happy with the result.

HAWAIIAN FLOWER CROSS

LEVEL ● ● ○ ○ NUMBER OF STEPS 10

A cross made of flowers is traditionally used to represent the change from Good Friday to Easter Sunday, and the flowers covering the cross are meant to represent life and joy. This version is made modern by using Hawaiian hibiscus flowers instead of the traditional lilies. In addition to being symbolic, the design is a pleasing image to learn to draw.

WHAT YOU NEED:

- Drawing paper
- HB pencil
- Eraser
- Straightedge
- Black fineline pen
- Coloring pens

1 Using an HB pencil and a straightedge, lightly sketch a vertical line and a horizontal line to form a cross shape.

Next, draw two lines on each side of the vertical line and two more above and below the horizontal line. (The outside lines will help determine the thickness of the cross.)

2 Close each end of the cross by drawing a line that is slightly wider than the thickness of the cross and then draw eight diagonal lines to the four center corners of the cross.

3 Lightly sketch six circles inside the cross to act as guides for the flowers.

4 From the center of each circle, draw a curved spike for the filament and then draw some small arches at the end for the anther.

Draw five petals from the center flower that extend from the base of the filament. (A good rule of thumb is to first draw two petals in the top portion of the circle, two on the sides, and one at the bottom.)

5 Draw the petals for the remaining flowers. (For aesthetic reasons, try to make all of the petals look slightly different.)

6 Draw two leaves on the underside of each flower, but add four on the top flower. The leaves should all point outward and away from the center of the cross, with the exception of the two bottom leaves on the top flower, which should point down toward the center of the cross.

7 Draw additional leaves to fill in some of the white space and then draw a leaf extending outward from each flower that falls at the ends of the cross.

8 Using a black fineline pen, trace over the image and then erase any guidelines.

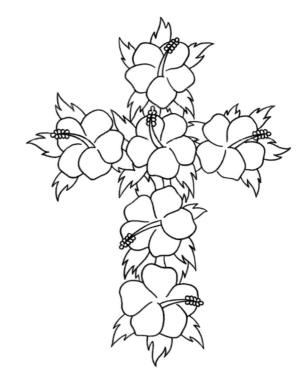

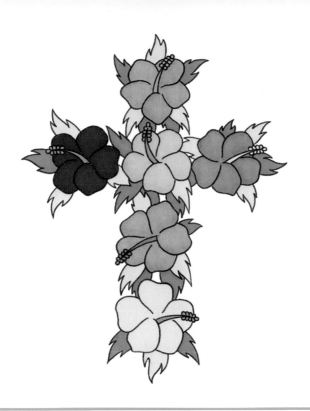

9 Use the coloring pens to add color to the drawing. Try using a unique color for each flower and then use different shades of green to add variety to the leaves.

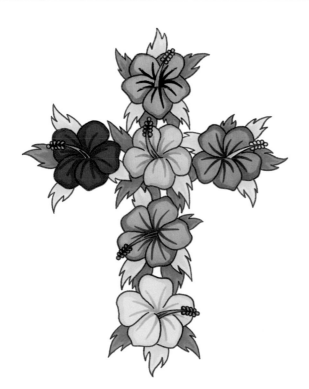

10 Using the same colored pens, darken the edges of the flower petals and leaves. Use darker colored pens to draw two lines from the center of each petal and also add additional detail to the filaments and anthers.

DRAGON CLAW & 8 BALL

LEVEL ● ● ○ ○ NUMBER OF STEPS 10

The 8 ball is the iconic black pool ball and the focus of the popular 8 ball pool game. The object of the game is to sink all of the other balls on the table before sinking the 8 ball to win the game. Because of this, the 8 ball is a popular motif for many artists. The 8 ball here is grasped by a gnarly dragon claw to create a very cool image.

WHAT YOU NEED:

- Drawing paper
- HB pencil
- Eraser
- Black fineline pen
- Black coloring pencil

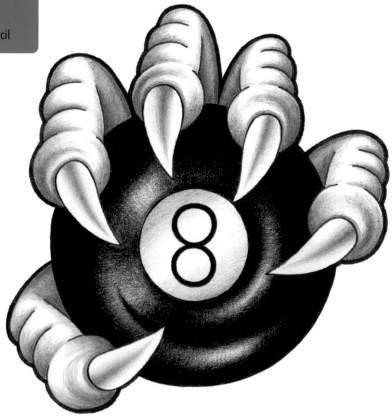

1 Using an HB pencil, lightly sketch a square and then split it into four parts by drawing horizontal and vertical lines through the center of the square.

2 Draw a curve inside each square to create a circle. (The square guide makes it easier to draw a circle, but don't worry if it isn't perfect.)

3 Draw a smaller circle in the center by marking four points at equal distance from the center point and then drawing four curves to create the circle.

Next, draw two smaller circles above and below the horizontal line to create the number "8."

4 Draw five circles for the knuckles around the outside of the large circle, adding four across the top and one to the lower left. (These don't have to be perfect circles. They just need to be more round than oval.) Add two smaller circles inside the numeral "8."

5 Draw arcs above each of the four knuckles across the top and then draw an arc to the side of the circle on the bottom left.

6 In the circles for the knuckles, draw pointy claws that almost look like teardrop shapes. Try to make each claw point toward the number "8."

7 Define the paws by drawing a curved line through each arc from the knuckle and then drawing two curves across the top of each paw to create folds in the skin.

8 Using a black fineline pen, trace over the drawing and then erase any guidelines.

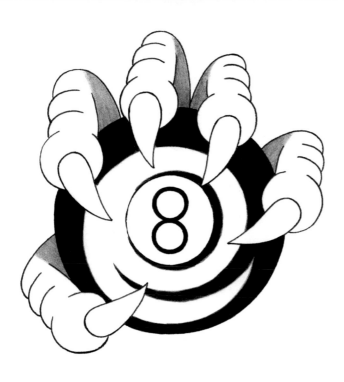

9 Using a black coloring pencil, shade around the outside of the 8 ball. Next, use the HB pencil to shade the darkest areas of the paws that sit behind the 8 ball.

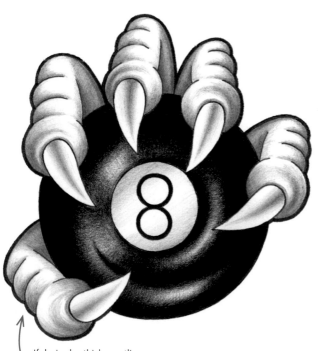

If desired, a thicker outline can be applied to the paws to enhance their appeal.

10 Continue shading the paws and claws with the HB pencil and then add a little shading inside the circle behind the number "8."

Lightly shade the white areas of the 8 ball with the black coloring pencil, leaving the white circle containing the "8" with the lightest shading and making the areas surrounding the white circle darker.

LEVEL ●●●○ NUMBER OF STEPS 10

The daisy is a small wildflower found in backyards and fields and is a symbol of purity, innocence, loyalty, and patience. In Celtic legend, God sprinkled daisies across the earth to cheer up parents who had lost a child. From a drawing standpoint, you can learn several good art principles from drawing a daisy—it's a good, relatively simple subject for a beginning artist.

WHAT YOU NEED:
- Drawing paper
- HB pencil
- Eraser
- Black fineline pen

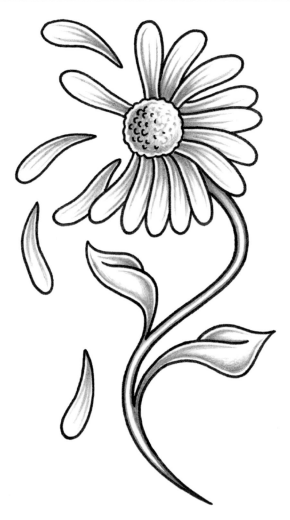

1 Using an HB pencil, lightly sketch a circle and then divide it into four sections by drawing a vertical line and horizontal line through the center. (The circle doesn't have to be perfect; a circular shape is good enough.)

2 Draw a small circle in the center and then draw two diagonal lines through the center point to create eight sections.

3 Draw a diagonal line through each section to create 16 sections. Draw a slight line at the bottom to represent the ground and then draw two side-by-side wavy lines for the stem that taper together at the bottom.

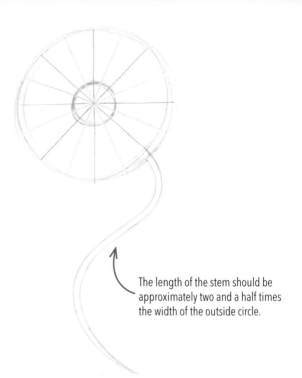

The length of the stem should be approximately two and a half times the width of the outside circle.

4 Now it's time draw some petals. Begin by drawing one petal at the top and then a couple more on each side of the first.

Next, draw two wavy lines on each side of the stem that taper in the same direction but don't join.

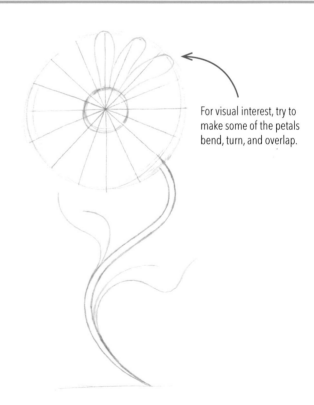

For visual interest, try to make some of the petals bend, turn, and overlap.

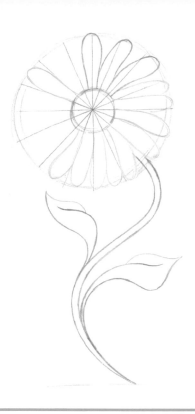

5 Connect the leaves by drawing a
 third wavy line on each leaf.

 Continue adding petals to the
 flower until just past the halfway
 mark of the circle and then add a
 single petal at the top left, leaving
 some space on each side.

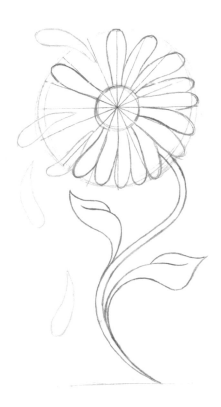

6 Draw two or three more full petals
 inside the open space but away
 from the flower's center, as if they
 have broken away. Draw two
 more below that appear to be
 falling to the ground.

7 Add some detail to the center of the flower by drawing a round serrated edge and then drawing some small arcs inside the left side of the center.

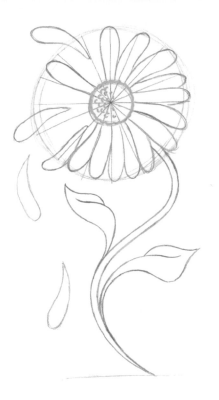

8 Use a black fineline pen to trace the image and then erase any guidelines.

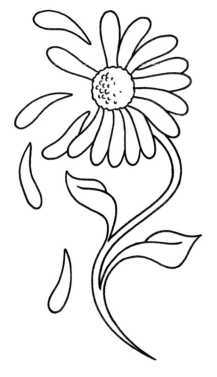

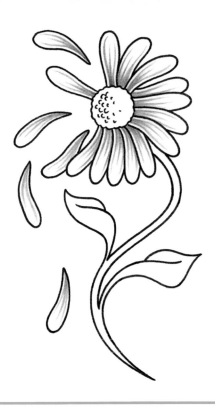

9 Using the HB pencil, lightly shade inside the petals, leaving white space along the inside edges and at the ends.

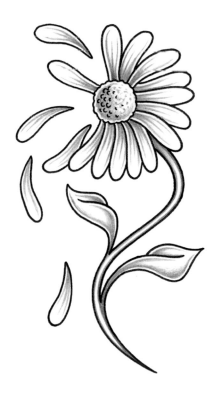

10 Lightly shade the flower's center and then further darken one side of the center. Darken the bottom ends of the petals and then darken around the edges of the stem and leaves.

MASQUERADE MASK

LEVEL ● ● ● ○ NUMBER OF STEPS 10

Masquerade masks, also sometimes known as Venetian masks, have a long history. They were first associated with the celebration of Carnevale but are perhaps best known for being worn during masquerade balls. From an artistic viewpoint, these masks offer countless ways to draw and decorate a basic starting shape.

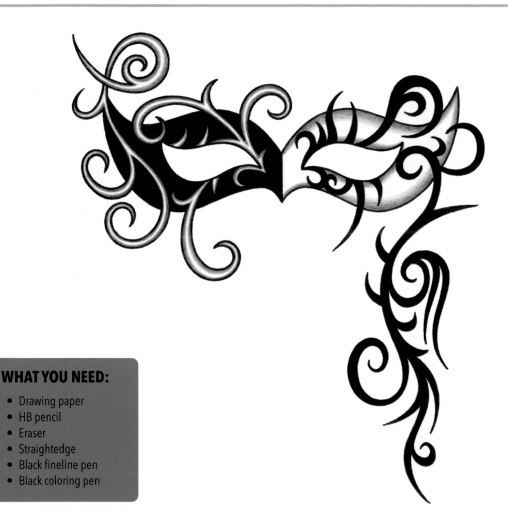

WHAT YOU NEED:

- Drawing paper
- HB pencil
- Eraser
- Straightedge
- Black fineline pen
- Black coloring pen

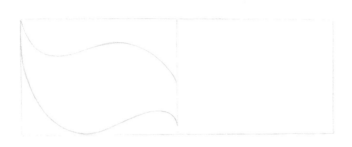

1 Using an HB pencil, lightly sketch a rectangle and then divide it into two halves by drawing a vertical line through the center. The length of the rectangle should be about two and half times the height.

Next, from the top left corner, draw two wavy lines that flow to the vertical center line to create a teardrop-like shape.

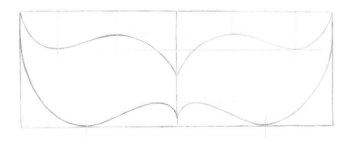

2 Repeat the same process on the opposite side. Begin by using the straightedge to draw vertical guidelines through the center of the widest points on the left side or where the lines bend and then marking additional horizontal guidelines to indicate the depth of the mask. Mark out the same points on the opposite side and then draw a matching teardrop-like shape.

3 Begin drawing shapes for the eyes by marking guidelines on one side where the lines will bend and then marking matching guidelines on the opposite side. Draw the eye shape on one side and then draw a matching shape on the opposite side. (Try to make these shapes flow in the same direction as the outside edges of the mask.)

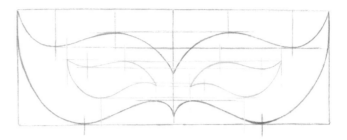

4 Erase all the guidelines and then draw a swirly line along the left side of the mask that extends above and below the mask.

5 Double up the swirl and then add additional swirls and flicks that taper at the ends.

6 Continue adding more design around the eye area.

7 Continue the design around the right side eye and then draw a design with lots of flicks and swirls that drops down. (Don't worry about symmetry. As long as the design style is consistent, it should all flow and come together.)

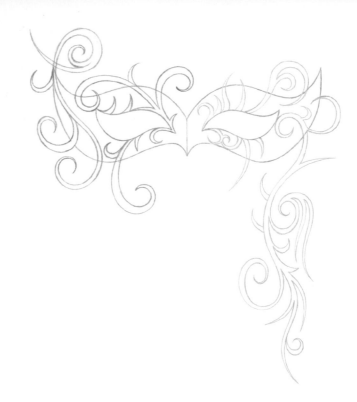

8 Using a black fineline pen, trace over the image.

9 Use a black coloring pen, fill in the mask area around the pattern on the left side and then fill in the floral pattern on the right side.

10 Using the HB pencil, lightly shade the outside of the floral pattern on the left side and then lightly shade the mask area on the right side.

LEVEL ● ● ● ○ NUMBER OF STEPS 10

An apple-shaped skull is an interesting image to create. An apple is often associated with health, while a skull is often associated with the end of life. Because of this, combining an apple with a skull makes for a fun and interesting drawing project that brings together contrasting concepts.

WHAT YOU NEED:
- Drawing paper
- HB pencil
- Eraser
- Black fineline pen

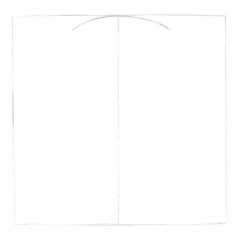

1 Using an HB pencil, lightly sketch a square and then draw a vertical line through the center of the square. Draw a slight curve inside the square at the top of the vertical line.

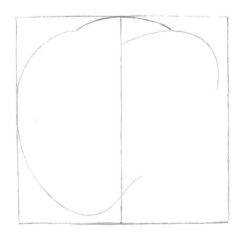

2 Draw another curve that almost looks like a letter "C," starting from the left end of the slight curve at the top. This curve should fall just above the bottom of the square and then sharply swing up and across the vertical line and toward the right side. Draw a smaller curve just below the right end of the slight curve at the top.

3 From the bottom of the center line, draw a diagonal line that points slightly up toward the right side and then draw another diagonal line that points up toward the left side.

Below the right side curve, draw a line that slightly bends inward but sharply bends at the bottom and then back up toward the left, connecting to the shorter diagonal line. Draw a third diagonal line that is parallel with the bottom diagonal line but connects the bottoms of the two curved lines on the left and right sides.

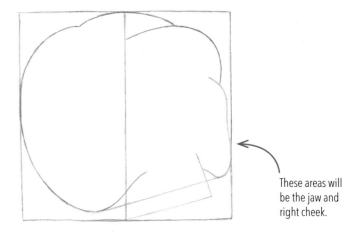

These areas will be the jaw and right cheek.

4 Draw a horizontal guideline through the center point of the vertical line. Draw the nose and then define the top jaw by drawing small upside-down curves. Draw a row of interconnected curves at the bottom for the teeth.

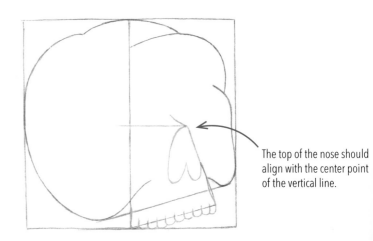

The top of the nose should align with the center point of the vertical line.

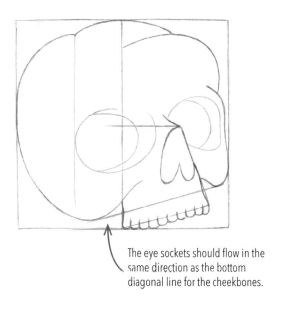

5 Draw a vertical guideline from the top of the "letter C" line from step 2.

Draw the eye sockets. The eye on the right should start just above the nose and curve at the top and bottom but follow the same path as the outside edge. Draw an egg-like shape for the eye on the left, but break the line at the top. Draw a curve on the inside of each eye socket.

The eye sockets should flow in the same direction as the bottom diagonal line for the cheekbones.

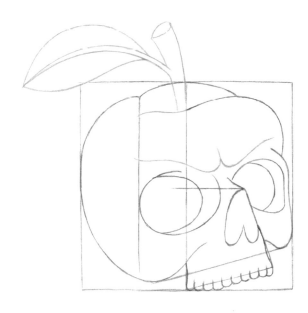

6 Draw a brow above the eyes. (The center of the brow should start just above the nose and in between the eye sockets and then spread up and slightly past the outsides of the eyes.) Draw a stem and a leaf at the top of the skull.

7 Use a black fineline pen to outline the drawing and then erase all guidelines.

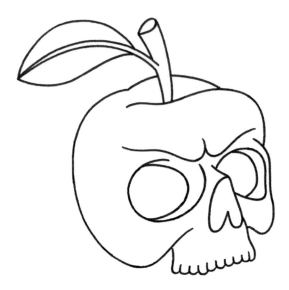

8 Use the HB pencil to shade some of the darkest areas around the edges of the skull and inside the eye sockets and nose. Shade the left side of the stem, along the lower edges of the teeth, and along the browline. Add some vertical shadows below the nose and above the teeth.

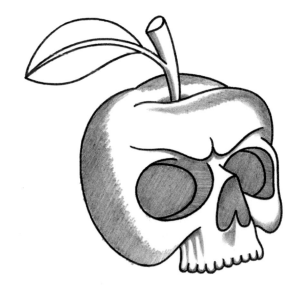

9 Continue adding shading to the darkest areas and applying lighter tones for the lightest areas. Draw three curved lines on each side of the leaf.

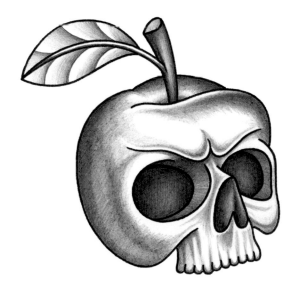

10 Apply dark-to-light shading inside the leaf, and continue shading the skull until you are satisfied with the result.

CHOPPER MOTORCYCLE

LEVEL ● ● ● ○ NUMBER OF STEPS 10

A chopper is a motorcycle that has been "chopped," or modified, from another motorcycle, or built from scratch. The way a chopper looks is what makes it truly unique. It's made up of a long, extended front end at a higher rake angle, a rear with no suspension, and either very high or very low handlebars. Choppers make a very cool subject to draw.

WHAT YOU NEED:

- Drawing paper
- HB pencil
- Eraser
- Black fineline pen

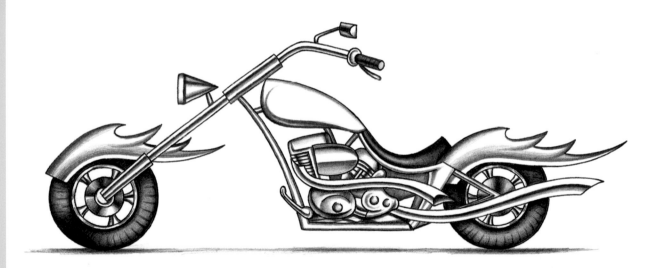

1 Using an HB pencil, lightly sketch a rectangle. The length of the rectangle should be approximately three times the height. Next, draw two squares in the bottom corners of the rectangle and then add vertical and horizontal lines to divide the squares into four parts. Draw curves inside the squares to create two circles for the wheels.

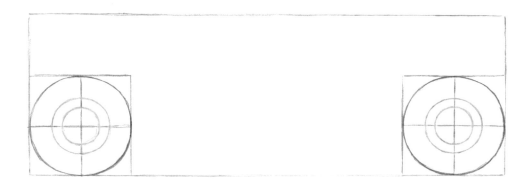

2 Inside each circle, draw a smaller circle for the inside edge of the wheel and then draw an even smaller circle inside of that.

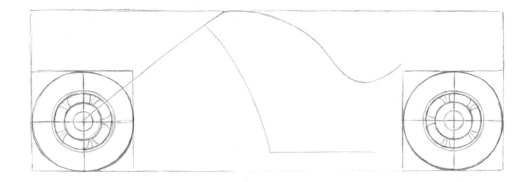

3 Complete the wheels by drawing a narrow space around the inside edge of each wheel, a smaller circle in the center, and curved lines for the spokes. Draw a diagonal line from the center of the left wheel to the top of the rectangle and then draw a curve that flows toward the bottom right wheel but then sharply bends back up and toward the right corner. Mark out a slight downward curve from the diagonal line and then add a horizontal line near the bottom of the rectangle for the outside of the motorcycle frame.

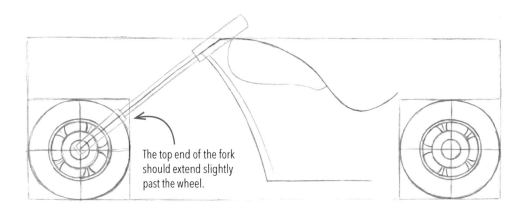

The top end of the fork should extend slightly past the wheel.

4 Draw two lines over the front wheel and on each side of the diagonal line to create the front fork and then close the lines on each end. Draw two more diagonal lines on each side of the first diagonal line that extend up to the top of the rectangle and then add two wider lines at the top of the diagonal line that are closed at the ends. Double up the left side of the frame by drawing another curved line that gradually tapers toward the top end. Draw a wavy line for the underside of the gas tank.

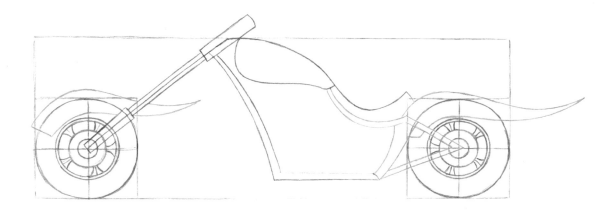

5 Complete the frame by drawing diagonal lines with the points resting on the hub of the right wheel and a double curved line below the seat. Connect the top and bottom of the right side of the frame with a diagonal line and a curved line. Next, draw wavy spiked shapes above each wheel for the mud guards.

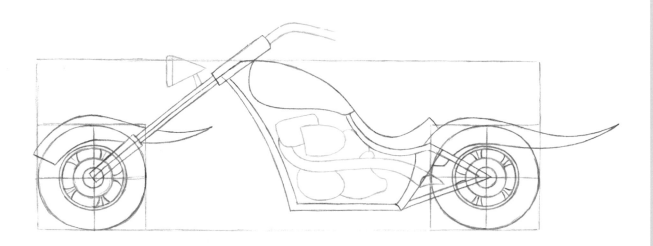

6 Draw a double curved line for the handlebar, a cone shape for the headlight, and some overlapping oval-like shapes for the engine components. Next, draw a long double wavy line for the exhaust pipe that runs through the center of the engine parts.

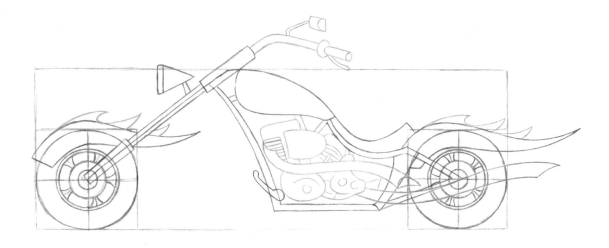

7 Draw a handle on the end of the handlebar with a mirror on top and then add some details to the engine parts. Draw a second exhaust pipe that extends from the back of the engine and swings across and past the back wheel. Add some spikes to the tops of the mud guards.

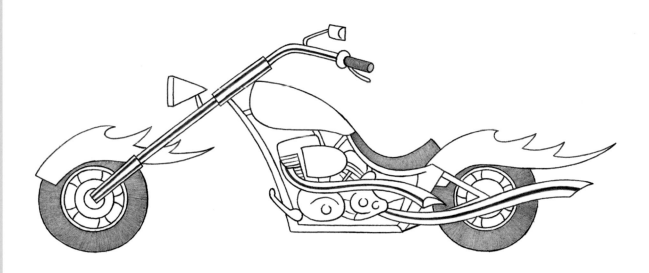

8 Use a black fineline pen to trace the image. Carefully erase any guidelines and any areas where parts overlap other parts. Using the HB pencil, apply medium shading to the tires, seat, and handle. (Try not to apply too much pressure at this point.) Add some darkened lines to the tailpipes, front fork, and handlebars. (These lines will add a highly reflective look to the chrome parts.)

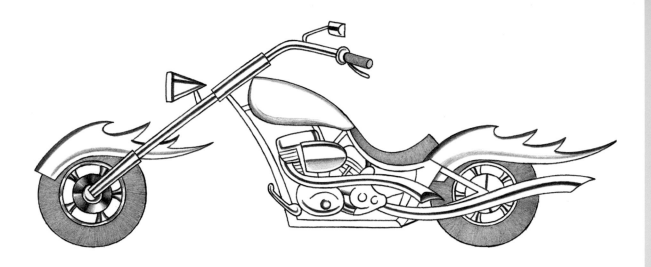

9 Continue adding light shading to bring out more detail.

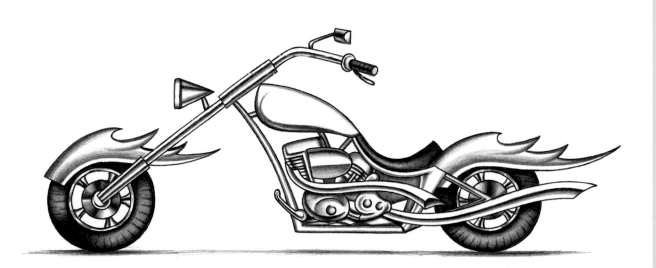

10 Apply additional pressure to add more shading to the darkest areas. Add a shadow underneath the motorcycle for extra effect, adding the darkest shading directly underneath the wheels and at the bottom of the frame.

LEVEL ● ● ● ○ NUMBER OF STEPS 10

Dice can be seen as a symbol of luck or awareness of the way fate can affect our lives—to throw a die is to take a chance. Besides the symbolism behind them, dice are just gratifying objects to draw. It's always good to know how to draw this basic shape, and adding the dots magically turns these cubes into something instantly recognizable.

WHAT YOU NEED:
- Drawing paper
- HB pencil
- Eraser
- Straightedge
- Black fineline pen
- White coloring pencil
- Tissue paper

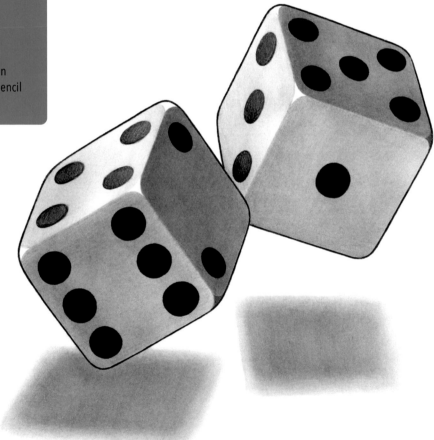

1 Using an HB pencil and straightedge, lightly sketch a cube that's tilted on its side. Draw the front-facing side first and then draw three parallel diagonal lines extending from the corners. The three parallel corner lines should be approximately three quarters the length of the front facing sides. Connect these lines by drawing two lines that are parallel to the front-facing top sides.

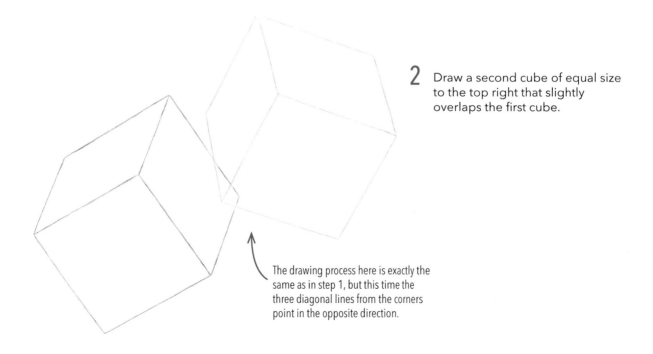

2 Draw a second cube of equal size to the top right that slightly overlaps the first cube.

The drawing process here is exactly the same as in step 1, but this time the three diagonal lines from the corners point in the opposite direction.

3 Round off the corners by drawing a slight curve along the edges of the corners and inside the corners.

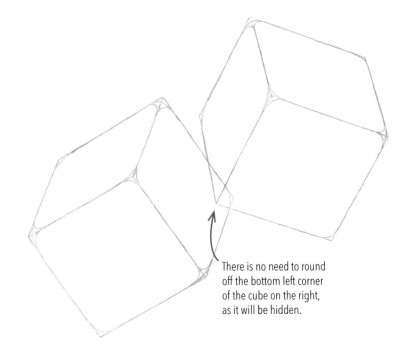

There is no need to round off the bottom left corner of the cube on the right, as it will be hidden.

4 With the basic dice shape in place, it's time to add some dots. Begin by drawing a horizontal guideline along the front face of one die and then drawing three vertical rows of evenly spaced squares on each side of the die face. (These will serve as guides and make it easier to draw all of the dots the same size.) Add six circles in the squares.

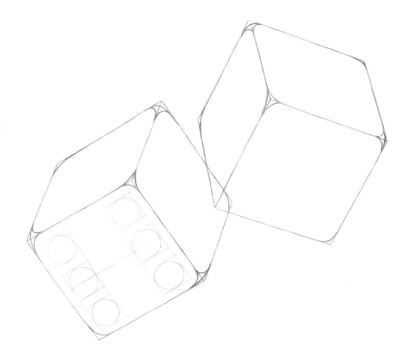

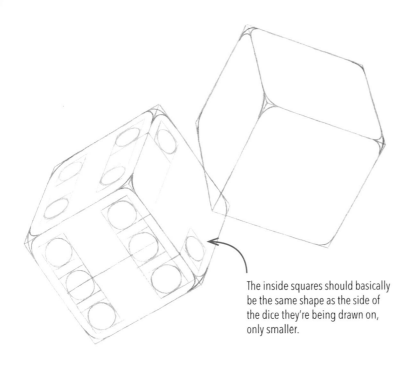

5 Draw four dots on the top left side and two dots on the right side. Note that these dots are more oval-shaped in appearance due to them being on the sides. However, just as in step 1, you will draw guidelines and then add the squares, but this time the squares need to be in more of a diamond shape.

The inside squares should basically be the same shape as the side of the dice they're being drawn on, only smaller.

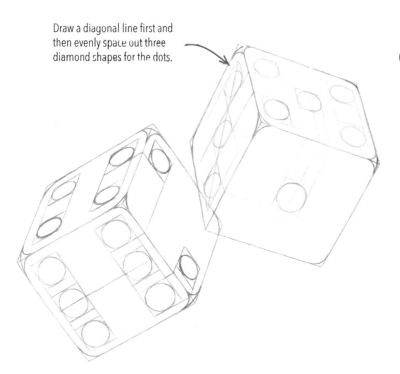

Draw a diagonal line first and then evenly space out three diamond shapes for the dots.

6 Follow the same process to add dots to the second die.

7 Trace the image with a black fineline pen, but leave the inside edges in pencil.

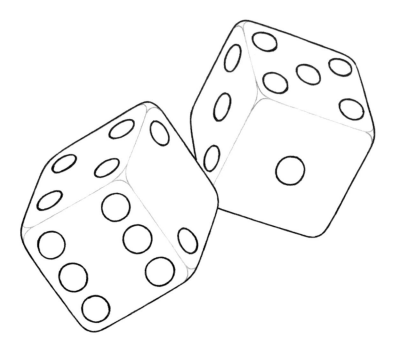

8 With the HB pencil, lightly shade the front sides of the dice and then shade the right sides of the dice with a slightly darker tone. Leave the rounded corners of the dice unshaded.

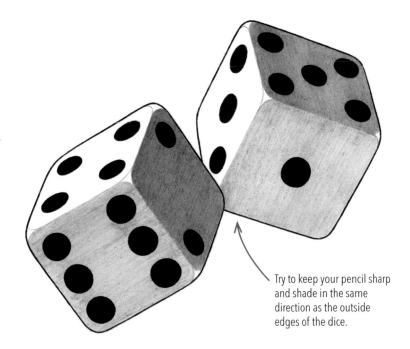

Try to keep your pencil sharp and shade in the same direction as the outside edges of the dice.

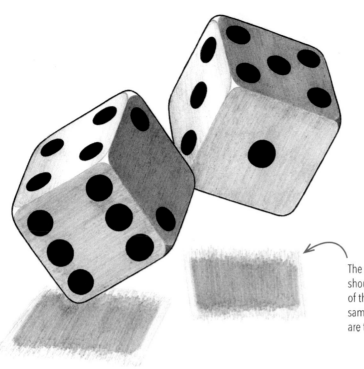

9 Carefully shade the lightest tone on the top left sides and then shade the darkest tone in the rounded corners on the right sides.

Next, roughly shade in some shadows below the dice.

The edges of the shadows should line up with the width of the dice and point in the same direction that the dice are tumbling.

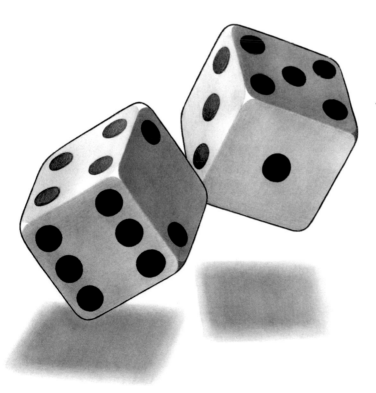

10 Using the tissue paper, carefully smudge over the dice and shadows. (Be sure to take your time and smudge only one side at a time.)

Use a white coloring pencil to lightly shade over the dots on the top left sides of both dice.

FAIRY

LEVEL ● ● ● ● NUMBER OF STEPS 10

Fairies are legendary creatures that first became popular among European cultures. Now, through stories and myths, the fairy has become popular with people across the world. There are lots of different ways in which fairies are depicted, but this version is a cute, spritely fairy who would be at home in any field of flowers.

WHAT YOU NEED:
- Drawing paper
- HB pencil
- Eraser
- Black fineline pen
- Coloring pencils

1 Using an HB pencil, draw a curved line that swings down toward the right. This line will determine the flow of the body.

Next, draw an arc at the top of the line and a circle on the top left side of the arc. The arc is for the top of the head, and the circle is for a flower.

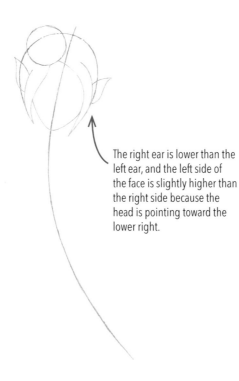

The right ear is lower than the left ear, and the left side of the face is slightly higher than the right side because the head is pointing toward the lower right.

2 Draw the hairline by drawing a curved line from each end of the arc up toward the circle and then draw curves on each side that taper at the ends. Draw two pointy ears that resemble teardrops and then draw a wide "V" shape with a rounded bottom for the sides of the face and the chin.

3 Draw petals and a small circle for the flower and then add a little detail to the ears by drawing a smaller curve inside the tops of the ears.

Define the hair a little more by drawing a couple of curved lines behind the right ear and a small one behind the left. Draw two small curves below the chin for the neck.

4 Draw two "V" shapes for the arm and then round off the right side of the "V" shape by connecting it to the right side of the neck for the shoulder.

Draw a large arc behind and below the arm for the dress and then connect the two ends of the arc at the bottom with a slight curve.

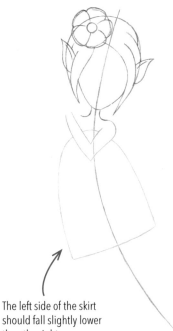

The left side of the skirt should fall slightly lower than the right.

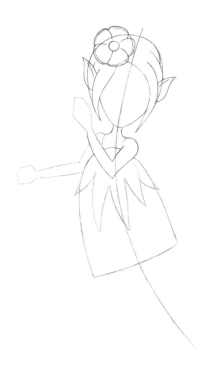

5 Draw the back arm and then draw guidelines for the hands. Next, draw leaf-like shapes inside the top portion of the dress.

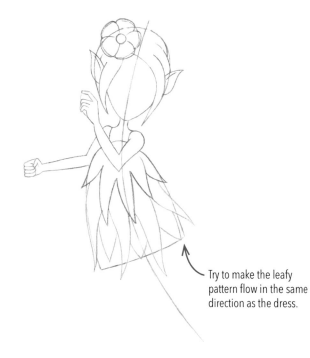

6 Draw the fingers and then add more leaf-like shapes to the midsection and lower part of the dress.

Try to make the leafy pattern flow in the same direction as the dress.

7 Draw the legs and feet, round off the elbow, and add a slight curve inside the arm. Draw a wand.

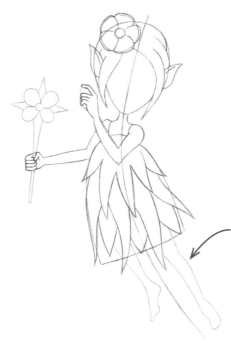

Try to make the legs flow in the same direction as the long curved line that runs through the center of the body. Be sure to make the front leg longer than the back leg.

8 Draw toes on the right foot and then draw the eyes, nose, and mouth. Mark out the wings.

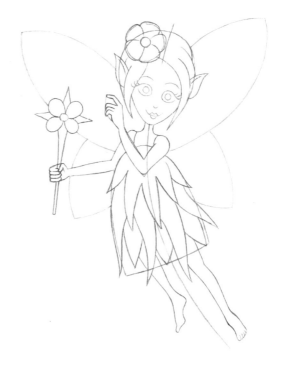

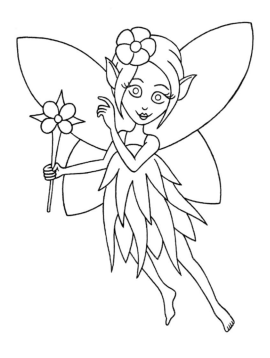

9 Using a black fineline pen, trace over the image and then erase the guidelines as well as any areas where objects overlap.

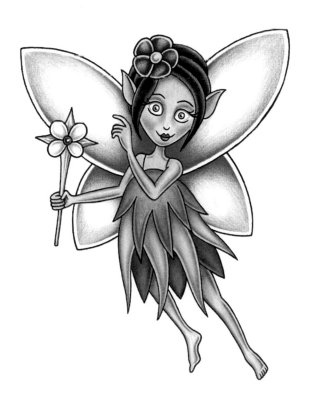

10 Use coloring pencils to color your fairy. Add shading along the edges of the wings and in the leaves on the dress. Use darker colored pencils to add details to the arms, legs, ears, hair, and face, as well as to the wand and flower.